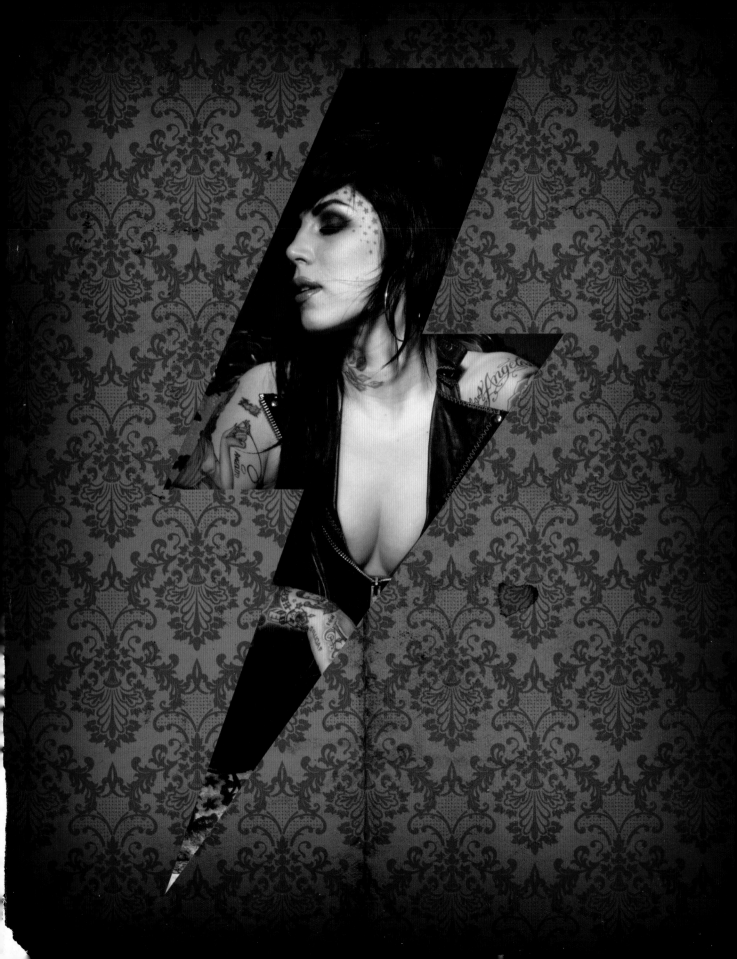

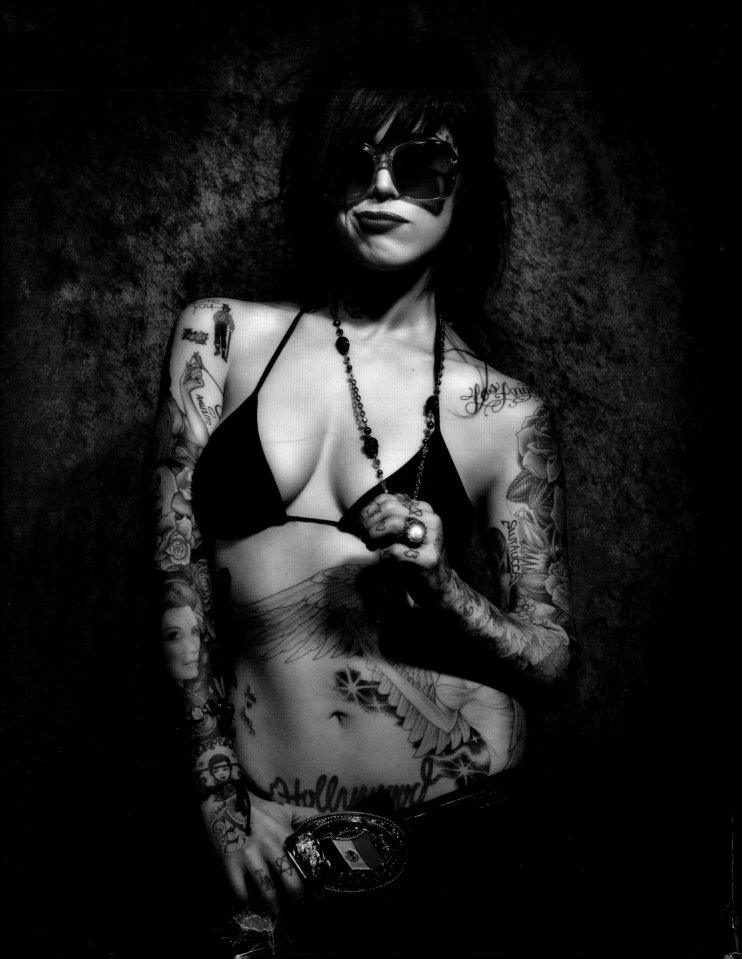

HIGH VOLTAGE TATTOO

BY

Kat Von D

PHOTOGRAPHY BY LIONEL DELUY

COLLINS DESIGN

An Imprint of HarperCollinsPublishers

For Karoline

Since day one, you have been the only one to believe in any of my crazy ideas — from falling in love and moving across the country on a Greyhound bus to tattooing. Aside from tattooing, you are the only thing that's been consistent in my life.

We share the same voice, laugh, sense of humor, shitty temper, and stubborness. I only wish you knew how cool I think you are. Even though our roles are often reversed and I end up treating you like my "little sister," I always wished so badly I could be like you.

Everything I do is for you. No one knows me as well as you do. No one loves me as truly and completly.

Without You — I'm Nothing.

HIGH VOLTAGE TATTOO

Contents

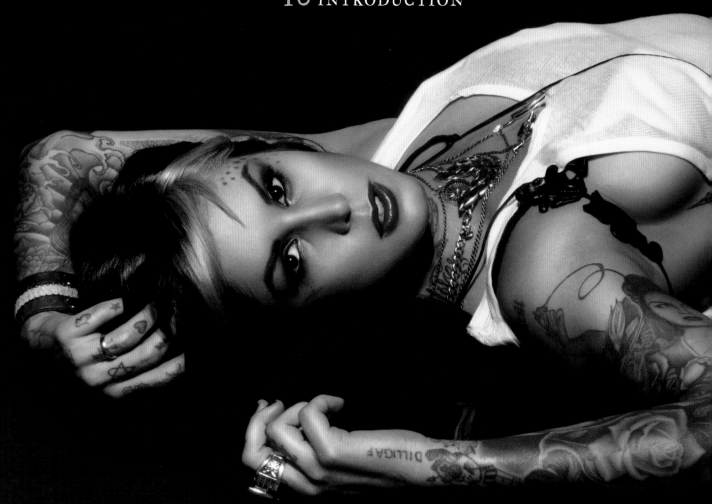

I DON'T

MEAN TO BE

FORWARD,

BUT THIS IS

A

FOREWORD.

NIKKI BY SIXX

SOME THINGS ABOUT KAT VON D ARE JUST PLAIN OBVIOUS.

She's wall-to-wall heavy metal, a B-52 bomber dropping nuclear F-bombs on full-tilt boogie, guns blazing, all the while balancing on top of eight-inch stripper platform shoes—and that's all before most people are out of bed. A statuesque beauty with a smile so addictive it hooks you in, when she walks into a room her presence completely overpowers you. That's why, for three seasons now, her fans have been watching Kat and her crew by the millions on the TV show *LA Ink* for a weekly Kat-fix. Like the wart on Lemmy's face, there's just no ignoring her.

She's defiantly a top-fuel funny car, a superhero cartoon character with a tattoo machine firmly in hand twenty-four hours a day. The saying "I'll sleep when I'm dead" doesn't even apply to her, 'cause she'll be tattooing an angel on Satan's shoulder when her time comes, and he will fucking love it, 'cause she is Kat Von D, Mistress of the Ink.

Now, here's what's not so obvious about KATHERINE VON DRACHENBERG. She can sit down at the piano and play Beethoven's Sonata in G Major from top to bottom with her eyes closed. She loves music and knows more about it than just about anybody I've ever met. She hates violence, and literally cannot hurt a fly. She always says "thank you" and "please," and feels bad when the bellman at a hotel tries to carry her bags. She loves fashion but hates to shop.

Okay, so you get it, every coin has two sides, but the saying is, there are three sides to every story. Here's the side of this girl that blew me away right off the bat: She has to tattoo. If she doesn't tattoo, she gets her panties all in a wad, and the wrath of Von D isn't one you want to see. Point is, the girl fucking loves tattooing. She can name any tattoo artist who has mattered, does matter, or is going to matter off the top of her head.

She's a true artist and she doesn't care about the celebrity (even though she's a fucking rock star). When she's done filming her show, she takes appointments and tattoos late into the night. She doesn't spend a lot of her time off going to chichi clubs and hobnobbing with the beautiful people. They come to her.

When she's in her element, she feels honest. In other words, "She ain't fucking around by hanging around!" She's got work to do. So you'll most likely find her with a lucky soul as she lays out a piece of art on their body that they'll carry for the rest of their lives, and that means more to her than just about anything in the world (except maybe peanut butter).

I've seen it a zillion times, when they walk out of the shop, and she's beaming, like a proud mama who's just given birth.

Last but not least, she gives credit where credit is due. I can't tell you how many artists she has turned me on to. Her voice rises in volume and her brows arch as she declares that "Not enough people know about Michael Hussar!" or "Kore Flatmo blows my mind!" or "Nikko has set the bar high!"

The list goes on, and you'll find out about these amazing artists and many others in this book. I've enjoyed watching her put this monster together, hours and hours of rewriting, scanning, digging in her past, and sometimes finding things that even she forgot about.

Her family, friends, and peers all proudly shouting from their lungs . . . "KAT VON D!"

If I know this woman as well as I think I do, she'll be the first tattooer on the moon.

OU GOT A ROSE ON THE HEART,

AN EAGLE IN THE MUSCLE, YOU

GOT THE SWEET JESUS HIMSELF,

SO COME IN TO ME. WEAR YOUR

HEART ON YOUR SKIN IN THIS LIFE.

—*Sylvia Plath*, "THE FIFTEEN-DOLLAR EAGLE," 1959

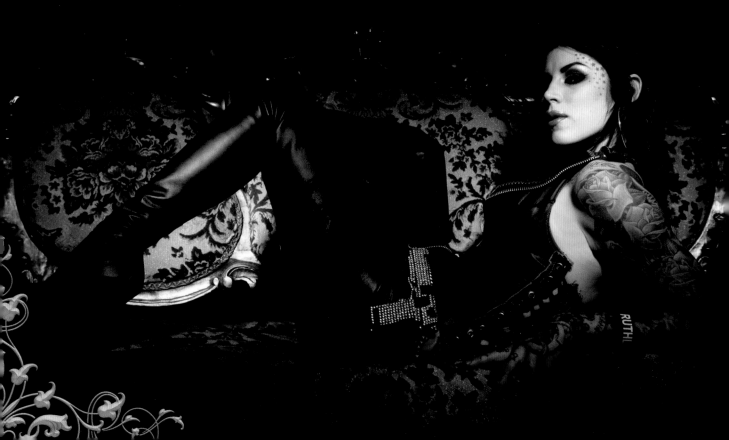

I STARTED TATTOOING when I was just a kid. I was fourteen years old. I didn't know anything—I didn't even know it could be a job. And you know what? Ignorance was bliss. I didn't know what I was doing, and I liked it.

I did my first tattoo because somebody asked. The experience thrilled me: It was brand new, but it was familiar. It was art, but it was more. Tattooing was like everything I had been working on in my notebooks since I was five, but more intensely concentrated. I was so young then, and I did it for the love.

Of course, we don't remain innocent. Our experiences shape us and they tarnish us. They make us strong and resilient, but they can lead us off of the path. I knocked on the door of the tattoo world, and I asked to come in—and when I got inside, I got lost in a maze. I wanted to immerse myself in art and technique and color and passion, but there were unexpected twists and turns: politics and egos and people who were trying too hard to prove that they were superstars instead of just nerds with tattoos.

Listen, I'm goofy. I'm a klutz and I'm silly. People assume that because I'm all tattooed, I'm tough. Or they think that I'm really kinky. But I'm actually pretty conservative! I don't tie dudes up in balls and chains, you know? I'm all about love. Love is my higher power. Family is my strength. Art is my passion.

When I was just starting, I wasn't emotionally connected to the tattoos I was doing—they were pictures I was creating, like the art I drew in my notebooks, and it stopped there. Now, more than a decade after I first picked up the machine, I have forged a new relationship with tattooing.

Whether I'm helping somebody cope or celebrate, when I give somebody a tattoo I become part of a landmark in time for them. The connection is something way beyond a needle and some ink. I can't magically take away people's problems and pain, but I can help them honor, heal, and rejoice. And that to me is the best gift I could ever receive. My tattooing is still about art, but it is also about sharing. The people I tattoo are the reason that I adore what I do. They make me feel connected.

But the politics, the pressures, and the overproduction were making me feel disconnected from where I had started. So here's what I've done this year: I broke up with the tattoo world, and I rededicated myself to the art and the people. I let go of caring what the tattoo world thought of me, and I kept caring about the people I was working with.

When I was a kid, I tattooed because I loved it, and not because I wanted my portfolio to get better, or I wanted A-list tattooers to think I was cool. Or because I thought I needed to prove myself because I'm a woman. Self-confidence is magic. In the time since I've stopped worrying what other people think about my choices, my art has actually improved.

Now, I tattoo. Period. Everything always comes back to tattooing. That's my life. People ask me what my hobbies are, and the answer is that I don't do anything but tattoo. Because even when I'm listening to music, playing the piano, or admiring somebody else's work, I'm learning and growing.

This book is about moving forward by looking back. Going through a life's worth of memories has been an incredible reminder of what is really important, and I hope it inspires you as much as it has helped me remember what inspires me: love, music, and art!

I want to do it because of the love, like when I was fourteen years old. So here I am. And here you are. Welcome.

HIGH VOLTAGE IS *MY* CHURCH,

the padded yellow table that I work on is my altar, AND THIS BOOK IS A LOVE LETTER.

The AUTOBIOGRAPHY

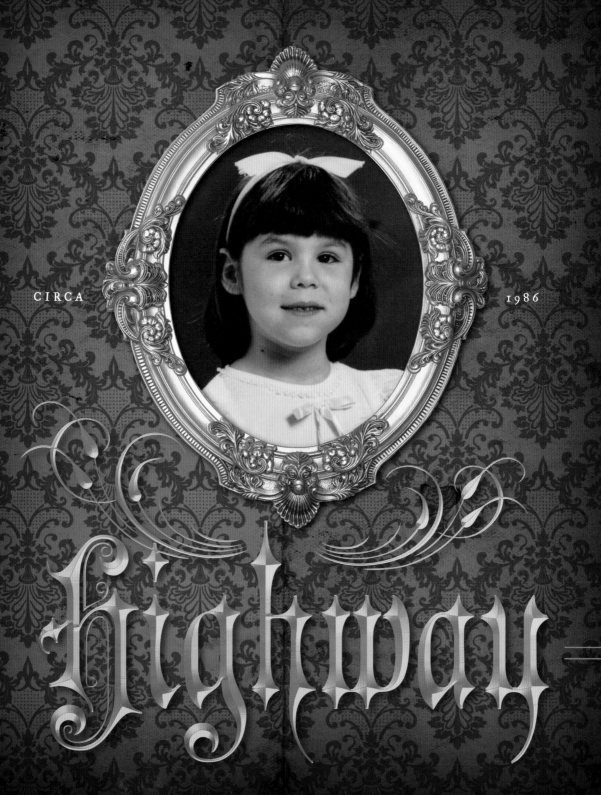

CIRCA 1986

highway

"I LIKE DESIGNS. DESIGNS ARE NEAT."—*KAT VON D, AGE 6*

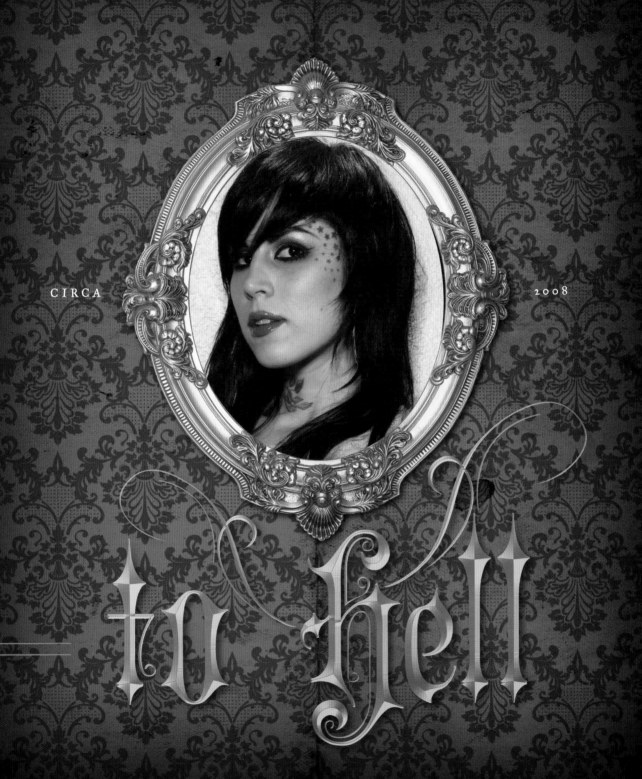

CIRCA 2008

tu hell

"EVERYTHING ALWAYS COME BACK TO TATTOOING."

WHEN YOU LOOK

At

B

D

Y

My

YOU

CAN

SEE

MY

MEMORIES

My dad and me in Mexico.

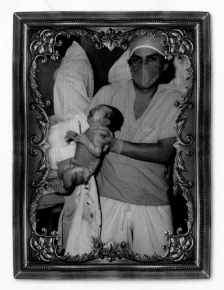

My grandpa delivering me—my
first seconds on the planet!

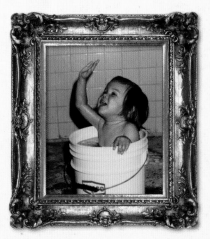

Taking a bath in a bucket
at age two.

I am a canvas of my experiences. My story is etched in lines and shading, and you can read it on my arms, my legs, my shoulders, and my stomach. But like everybody else, I was born naked and screaming, waiting for my life to write itself on my skin.

The first person who ever held me was my grandfather, Carlos Von Drachenberg. He was the doctor who delivered me in March 1982, in Montemorelos, Nuevo León, Mexico. I come from a long line of doctors. When I was born, my grandpa was teaching medicine in Mexico as a missionary for the Seventh Day Adventist Church while my father finished his schooling in the medical field. My family came from Argentina, but until I was four, we lived in Mexico.

I can still remember the dirt roads, the horses and donkeys, the rain that flooded the pool with frogs, and the local market where my sis and I used to run around and play. And many of my tattoos, especially the lettering, are in Spanish, reflecting Latin tradition.

But my strongest memories are set in Colton, a small town in Southern California, where my life revolved around love, art, and music. In our family, love was a given, art was a powerful presence, and music was

pretty much a requirement. The five of us — my parents, my older sister, Karoline, and my younger brother, Michael — listened to religious hymns at church, but at home, classical music was everything.

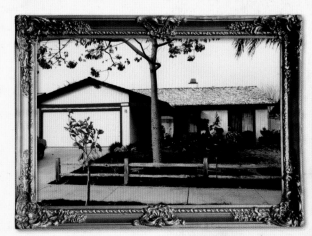

Our first house in America, Colton, CA.

My grandmother, Clara Von Drachenberg, was an inspiration for me when it came to music and art. She classically trained my siblings and me to play the piano. For breakfast we had Chopin, for lunch we had Mozart, and as an after-school snack, Schubert and Liszt. But above all, there was Ludwig van Beethoven.

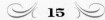

During our weekly lessons, I would sneak into her library to catch a glimpse of a scrapbook she had put together during her teenage years that was dedicated to her favorite composers, Beethoven being the main one. On my eighteenth birthday, Clara gave me the scrapbook as a gift, and to this very day, that book is probably one of my most prized possessions. And Beethoven still features prominently in my life — I have four tattoos of him, countless paintings, and one of my cats is named Ludwig.

A page from my grandmother's scrapbook.

A vintage photo of Clara.

A portrait Clara drew of Beethoven when she was sixteen.

Clara was my mentor in all things music; when it came to art she was more like a role model. I have a still life of an arrangement of roses, dated 1949, that Clara gave to my parents as a wedding gift. It hung above the fireplace in our family room, where I practiced the piano, and I spent my childhood staring at it and imagining her painting it.

I coveted that oil painting. When my parents divorced after twenty-six years of marriage, the painting went with my father, and I begged and begged him for it. My father disagreed, always trying to negotiate his way out of giving it to me. Finally, on my twenty-sixth birthday, as a gift from both Clara and my dad, I was given the painting!

The inspiration to create my art and the encouragement to continue my musical studies paved the way for me to create the life I lead today, and I thank my grandmother for passing these gifts on to me.

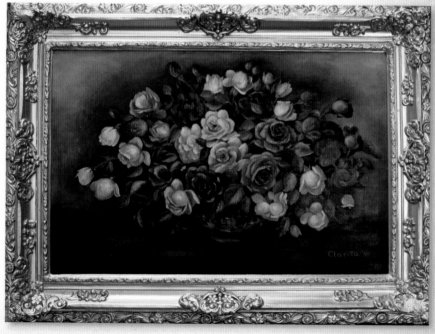

My grandmother's painting.

Our whole family was musical. Between us, we could play the accordion, trumpet, guitar, piano, clarinet, bass guitar, saxophone, harp, and flute. Unlike most of my childhood friends, who played outside or went to slumber parties, we practiced our weekly lessons two hours a day, whether or not we wanted to. I can remember crying because I didn't want to play—but I still had to practice. It wasn't fun at the time, but it taught me that if you dedicate yourself to something, you'll get there. It is a lesson that still impacts the way I work today.

It was in elementary school that I really discovered my passion for art. I spent a lot of my time drawing pictures of my family, of flowers, of birds; all the things that I saw around me. My father still talks about the way I would crawl under the pews at church, coloring furiously while everybody else listened carefully to the sermons. Every year, I got better at drawing. I was drawing constantly, filling up one pad after another with my sketches and dreams. My mother saved every piece of art I did, whether I liked it or not.

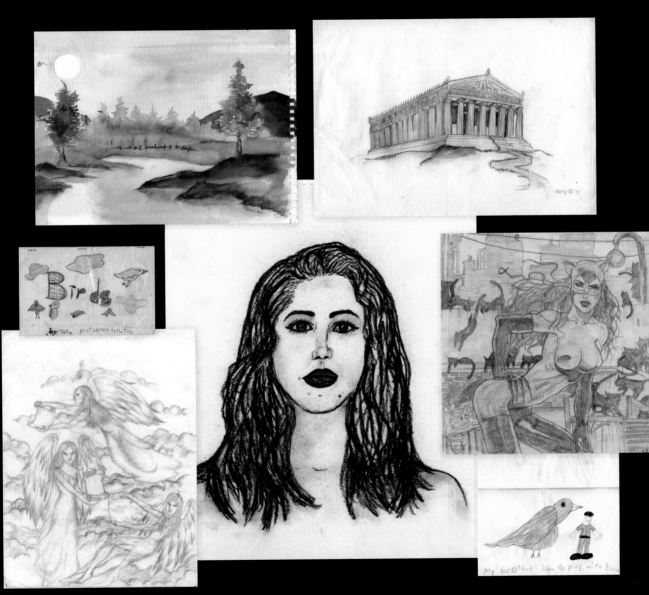

CLOCKWISE FROM TOP LEFT: My only attempt at watercolor, age seven. • Pretty damn good for a ten-year-old! A comic drawing, age nine. • I was already writing books in the first grade. • A charcoal drawing I did of my sister, Karoline, when we were in elementary school. • One of the sketches I did under the pews at church. • The cover for the bird book shown at bottom right.

From the very beginning, I gravitated towards realism, working hard to render lifelike portraits of family members, pets, and magazine clippings. I wanted my drawing to look as real as possible and would practice on famous faces like Marilyn Monroe's. When Anna Nicole Smith was cast in the Guess ads in the early 1990s, when I was around ten, it was a turning point for me. At the time, I didn't even know her name, but she was such a classic beauty, like a modern Marilyn Monroe or Jayne Mansfield, that I was inspired to sketch her. I must have drawn her face more than twenty times. Each time, I tried to do better, perfecting my lines and shading so that I could noticeably improve the drawings.

long after she died, I received an e-mail from one of her close friends who wanted to get a portrait of Anna tattooed on her thigh.

When Anna's friend showed up at the shop with her personal collection of photographs, I rifled through the stack to find the image that would make the best tattoo. And then it hit me: The blonde in the pictures sipping coffee in the morning wasn't just a pop icon, or the headline of the month, or another playmate. She was a real person who had played a big part in the development of my art. I had learned to draw faces by staring at her face, and now, after her death, I was going to tattoo her portrait on her friend's skin as a loving memorial.

At that moment, I felt like I had completed a circle in my life.

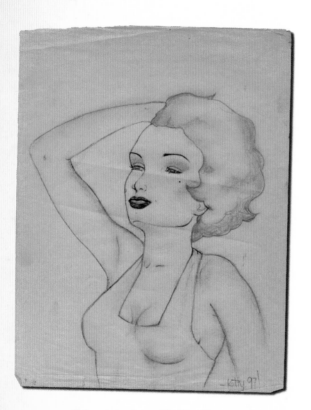

*I loved to draw Marilyn Monroe.
This is from when I was about ten.*

When she passed away in 2007, the tabloids were buzzing with gossip and rumors, but there were some people who were genuinely sad about her death. Not

*I was just thirteen, but you could
see in my eyes that I was trouble!*

Problem Child

FOURTEEN CHANGED EVERYTHING. That year, I fell in love, discovered punk rock music, got my first tattoo, and dropped out of school.

My first experience with love turned me inside out and back again. It was such a gnarly feeling. If you had asked me to jump off a cliff for James, I would've done it in a heartbeat. He took my breath away. I can't explain it any other way.

James was two years older than me, and he had gone to school with Karoline. He had a huge black Mohawk, tattoos, and wore eyeliner, and the first time I met him, I knew something big was going to happen.

We were inseparable from the start. We saw each other every day, which didn't make my parents happy. They were so conservative and old school that they had a hard time getting past how James and I looked together. My parents had a picture of how my life would work out, and James didn't fit into that vision. The trouble was neither did I.

No matter what they did to try and separate us, it always backfired. Keeping us apart only made us more desperate to see each other.

James was the reason for my first tattoo. I loved him so much that I let an inexperienced neighborhood punk rock kid named Oliver Guthrie tattoo a crude Old English J on my ankle. Guthrie gave me my next three tattoos, a New York Dolls pinup on my upper left arm, a rose and a wrench on my right calf, and a flaming music note on my left shoulder. They were so shitty that I had them all removed years later.

Back then, we all painted our leather jackets with logos of our favorite punk rock bands like the Misfits and the Ramones. Guthrie liked how I painted and wanted to know if I'd tattoo the skull logo from the Misfits on him. I was stoked when I tattooed him for the first time. Instantly I knew, much like when I met James, that tattooing was a path in life I was meant to take. Still, I had no idea that tattooing would

This is the first tattoo I ever did. This photo was taken recently so Guthrie had time to cover some of it up. Smart boy!

My second tattoo, done with a homemade rig and guitar string. (Do not try this at home!)

This is a tattoo design I drew for James and later tattooed on him. It was the third tattoo I ever did.

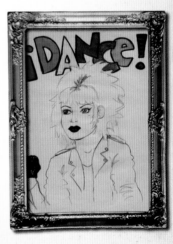

¡Dance! When music became influential in my life, it showed in my art.

become my lifetime companion, let alone my career. Two years went by, and my parents still couldn't accept my choices or James. Part of the problem was that I had stopped going to school, and part of it was the stigma attached to tattooing, which society associated with crime, drugs, and immoral behavior. But I knew that tattooing wasn't about immorality. It was about individuality. And I wanted to be an individual!

Eventually, my parents wouldn't let me see James anymore, and I freaked out. James and I decided to move across the country. I packed up my tattoo machines, some clothes, my cassette tapes, and my rolling tobacco, and we took a Greyhound bus to Georgia. It was hard to leave my family, but there was no way I was giving up James. Running away felt like the only solution.

My dad in the 70s.

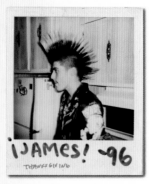

Left: James in 1996, shortly after I met him.
Right: Me at the Greyhound station on my way
to Georgia.

As I arrived in the kitchen, my sister was patiently waiting. Karoline was 16. I slipped out of the front door and into the car. Karoline joined, and then my mother got behind the wheel, ready to take us to the bus stop to school. We were off! And for a second, I was excited and thought it would work. I would run away to my destination, and live my own life.

My journal entry the day I ran away from
home at age fourteen. Sorry, Mom and Dad!

MY POOR PARENTS!

I still feel guilty about what I put them through. They had no idea where I was or how I was doing, and I was too scared to call them, because I knew inside that what I was doing wasn't right. I could feel myself growing up fast, and I quickly learned how to be on my own and support myself.

Three months later, I realized that I couldn't keep it up. I missed my family. I got back on a bus to Southern California, and James stayed behind to take care of loose ends.

I remember saying goodbye to James and getting on that bus. I remember sitting near a window and watching him cry as the bus pulled away. And I remember knowing that this would be the beginning of the end of us.

These days, I oftentimes think of James. I wonder where his life has taken him, and how he's doing. I wonder if he has covered up the tattoo of my name on his neck, or if we'd even recognize each other now. I haven't covered my J, and I never plan to. My first tattoo may be small and crudely drawn, but it is one of the most important in my collection.

Sin City Tattoo

Me at fifteen with my sister. It's apparent that I was listening to lots of the Plasmatics at the time.

When I got back to Southern California, I kept tattooing all my friends, trying to get better. I realized that I wanted to take my tattooing to the next level, so I thought that the best thing to do would be to surround myself with professional tattoo artists. The best way to do that was to get a job in a shop.

The first shop I worked at professionally was called Sin City, in San Bernardino. I walked into that shop even though I was terrified of rejection, because I was so inexperienced and because of my age. I was sixteen years old. Legally, I shouldn't even have been able to get a tattoo, let alone tattoo anybody else.

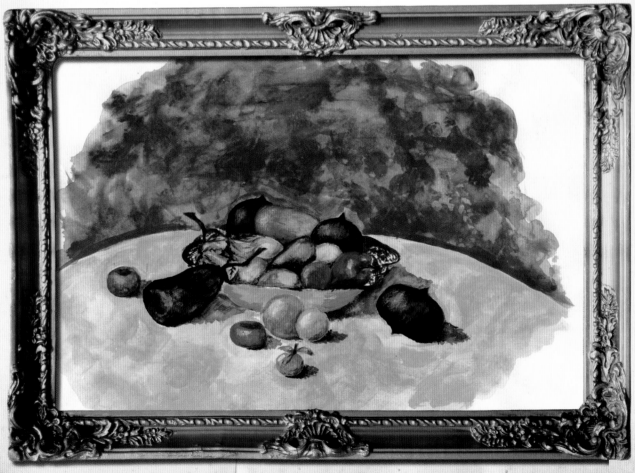

Still life done in oils, age sixteen.

The owner was an intimidating, old-school biker named Dave, who quickly skimmed through my poor excuse for a portfolio while deeply inhaling his cigarette. He was not impressed. He tossed my portfolio to the side and turned his attention to my sketchpads. I waited for him to ask me to leave. He didn't.

"You've got it," he said.

Dave saw something in my artwork, and he gave me a shot even though my history with tattooing was far from traditional. Most tattooers go through an apprenticeship, where an experienced tattooer walks you through the process at the pace he sets for you. This is something I never had. My apprenticeship consisted of trial-and-error practice on my underage friends, who wanted tattoos but couldn't get the work done at the local shops due to the age restrictions. When I got to Sin City, before I could learn what to do, I had to unlearn everything I thought I knew about tattooing.

The moment I started working with Dave, he made me take the mandatory cross-contamination first aid courses that I needed to get my license. He showed me the tricks of the trade—how to make needles, how to prepare stencils, and a little bit about machine building. These were all things I would have already known if I had been properly trained. For an entire year I went to work almost every day, eager to tattoo and learn something new. My grandmother's rigorous insistence on practice paid off. Days off were as foreign to me then as they are today.

The clientele that came through that shop typically included thugs, gangsters, homeless people, punks, prostitutes, hoodlums, and junkies, but I felt right at home. I wasn't a thug or a punk, but I could relate to them because they were real people living in very tough situations.

There was a jailhouse a few blocks away from Sin City, so there was a constant stream of newly released inmates coming into the shop with artwork they had accumulated during their time in jail. These intricately detailed collages were perfect for tattooing and played

an important part in influencing my tattoo style. I'd take those raw ideas and improve them by putting my own spin on them. Meanwhile, I was still practicing my fine art at home.

At Sin City, fine-line black-and-gray tattooing was the most popular style. The clients would come in asking for memorial tattoos, renditions of pachuca-style women in clown makeup or fedoras, portraits of low-rider cars, and Old English or *script-type* lettering. A lot of the work was gang-related. I tattooed hundreds of names and covered up even more.

"SIN CITY TATTOO: WE DO BETTER COVER-UPS THAN THE L.A.P.D."

—SIN CITY SHOP MOTTO

After about a year, I decided to leave Sin City. The experience was invaluable, and it shaped the way I tattoo today. But after a year, it was time to move on to another shop. The neighborhood was getting worse by the minute, but that wasn't the problem. While I had learned a lot, I was no longer growing artistically. The people I worked with were either too wasted to show up to work, or they had parties at the shop and I would come in the morning to find the leftover mess. I needed more. It was time to go.

It's a Long Way to the Top

(IF YOU WANNA ROCK 'N' ROLL)

{ "TIP THE WORLD OVER ON ITS
SIDE AND EVERYTHING LOOSE
WILL LAND IN LOS ANGELES."
—FRANK LLOYD WRIGHT
(1867–1959) }

It was always my goal to live in the City of Angels. I remember when Karoline turned sixteen and got her driver's permit, and we would sneak off to L.A. without telling our parents. We would jump in her green Toyota and head to Hollywood, even if we only had a few hours. The closer we would get to downtown, the bigger my heart felt, thrilled and scared at the same time. It was like falling in love.

We were just kids, and we had no idea where to go, so we went everywhere. We would wander up and down Hollywood Boulevard, going into the wig shops and the vintage stores and the rock 'n' roll shops to check out their concert T-shirts and studded bracelets. Even though we had no destination, I always felt like we had arrived.

"One day," I would tell Karoline, "no matter how hard it is, I'm going to live in L.A."

When the option presented itself, leaving my hometown wasn't hard. I didn't have many things to move, and my friend Sonya had offered me a room to rent in her house in Pasadena.

As soon as I moved in, I started looking for work, but finding a shop where I could tattoo was incredibly intimidating. Thanks to the local phone book, I had a long list of tattoo shops to check out, but after a week of trying, I realized that it was going to be even harder than I thought. In San Bernardino County I was a big fish in a little pond, but in L.A., everything was different.

Over and over again, the same thing would happen. I would walk into a tattoo shop. I would take a good look around the place and flip through the portfolios. And then I would walk out. The portfolios were devastating to pore through, because they were photographic proof that my tattooing skills were not very extensive. Humiliated by the other artists' work, I walked out of each and every shop, too ashamed to even ask if they were hiring.

The last tattoo shop on my list was Blue Bird Tattoo on Colorado Boulevard. I walked in, and it was completely dead. No one was giving or getting tattoos. The only sign of life was a man in the back who was chatting on the phone casually, as if he was just killing time. He hung up when he noticed me. I had no choice but to speak to him, so I told him that I was new to the area and looking for a job at a tattoo shop.

I didn't know it then—even at this nearly abandoned shop I was ready for rejection—but Pete Castro was about to save me. When he heard what I was looking for, his eyes grew big and round. Two sentences later, he was handing over the keys to the shop, giving me the alarm code, and adding me to the schedule.

He didn't even know my last name.

I wondered why he was so desperate, but I was desperate too, so I didn't ask. I learned the reason during my first week at Blue Bird. Pete was the only artist working at the shop. Period. He had a beautiful little ten-year-old daughter, but he hadn't been able to spend enough time with her because there wasn't anyone else to cover the shifts. Lucky for me, Pete really needed a day off!

Instead of being offended, I was grateful that I had been in the right place at the right time. Working with Pete turned out to be just what I needed. For more than a year, it was just the two of us working side by side. I

watched him tattoo, absorbing new techniques. He spoke highly of the masters of black-and-gray tattooing, showing me examples of their work in all of the tattoo magazines. I still credit Pete for turning me onto the likes of Jack Rudy, Filip Leu, Paul Booth, and a few other tattooers who were legendary for their fine-line black-and-gray tattooing.

Pete's mentoring helped me see tattooing in a different light. Before Blue Bird, I didn't really understand the spectrum of tattooing skills. But thanks to Pete, I noticed the differences in smooth gradations of black and gray versus choppy shading. I could distinguish flawless single needle lines from inconsistent line work, and I appreciated the difference between solid bright pigments and patchy faded colors. This new way of seeing things helped me understand the weak spots in my own tattooing, and my skills evolved and strengthened.

Sailor pinup sketch.

As I got better, I began to think more and more about the art of creating realistic portraits. I wanted to be able to precisely simulate a photograph of someone, rendering an image that might even be better than the original photo. I knew my skills weren't there yet, so I patiently practiced my black and grays, trying to turn the beautiful pinup girls of Alberto Vargas, Gil Elvgren, and George Petty into tattoos. I would choose the most realistically rendered girls from my collection of pinup art books, and then I would find friends willing to let me practice on their arms and legs. I practiced until I thought that my translations of those iconic images were nearly, if not completely, accurate.

I continued my portraiture education by watching some of the masters of the form up close—as they worked their magic on my arms. I set up several appointments, not only with Pete, but with Jack Rudy himself!

Jack Rudy is best known as the "godfather" of black-and-gray and portrait tattooing. I used to pore over tattoo magazines like a kid who just discovered *Playboy*. Of all of the portrait tattoos in those magazines, Jack's work stood out the most. I just couldn't wrap my mind around how he managed to get the tattoos to look so real.

To this very day, when I close my eyes, I can see one of his tattoos clearly. It was a beautiful portrait of a woman from the 1940s or 50s tattooed onto a man's rib cage. Jack had represented it as an actual photograph, complete with classic white borders. On top of that, he had tattooed a piece of Scotch tape on each corner of the "photograph." Somehow, Jack had managed to make it look like there was an actual photograph physically taped to this man's side!

My first appointment with Jack was set for a Thursday evening at 9:00 P.M. at Tattooland, Jack's shop in Anaheim. It had taken a couple of months to get the appointment, and I was stoked. Everyone and their mother had warned me that Jack was famous for being perpetually tardy, sometimes showing up hours after he was expected! I figured that if my appointment was at 9:00 P.M., I would show up at 11:00 P.M., so that I would

only have to wait three hours instead of five.

Of course, when I walked in, I found Jack sitting there patiently. My plan had backfired— Jack had been waiting since 9:00 P.M. on the dot! I was so embarrassed that I made up an excuse about car troubles, and sweet ol' Jack was not annoyed in the least.

Painting of a pinup, done at age sixteen.

Instead, he was worried and concerned about my car problems. I can't remember the last time I felt so bad about lying or being late.

We finally began the tattoo process. I had a space on my right forearm. It was the perfect place on my body to get a tattoo, allowing me to sit and watch Jack work in order to take whatever helpful techniques I could back with me to my shop.

Jack had a reputation for tattooing women's faces in a particular style, and only he could really pull off the look. His women had big eyes, long lashes, lips highlighted so that they looked as if they were glistening, and hair that seemed to flow along at least a billion strands. And that's exactly what I wanted to learn how to do.

Using a ballpoint pen, he drew on my arm with such finesse that he made freehand tattooing look easy. Two hours later, in between chapters of his autobiography, he had mapped out the face of a beautiful anonymous woman. And off we went!

For the next several hours, Jack and I talked about many things, but mainly about Jack. He told me about how he started back in the day, originally as a sign painter from East L.A., which explained his skill in lettering. He went on and on about the politics of the tattoo world, and while I didn't know a lot about it, he gave me a crash course that night.

By the time 6:00 A.M. rolled around, I could barely keep my eyes open. And it wasn't just the tattooing that took forever—Jack really liked to talk. But when Jack announced that my tattoo was finished, I looked down at my altered forearm, and I saw something incredible there. The smoothest gray tones were laid out across the woman's face. Each microscopic eyelash was perfectly aligned. It was unbelievable. Jack sat back, looking quite proud of his latest creation, and he told me that it was the best tattoo I had yet. I agreed. I still think it's one of my best tattoos, and it's definitely one of my favorites!

When I look at that tattoo, I think about a lot of things. The night that Jack tattooed me, I had been in the business for less than three years. Jack Rudy was like some kind of unattainable legend that I looked up to. Fast forward to now, and he has become my peer. Although we have different views about tattooing, I can talk to him like a fellow tattooer, and the respect we have for each other feels mutual.

Jack didn't only give me a tattoo that night—he also gave me some great advice. He said, "Kat, no matter what you're tattooing, never give less than 110 percent. It doesn't matter if it's a peace sign the size of a dime. You make that peace sign the best damn peace sign around!"

My Jack Rudy tattoo makes me think about the respect we owe to the people who came before us. If it weren't for artists like Jack, tattooing wouldn't be where it is now.

I remember going to visit Mexico a few months after I got the tattoo. I was in a tattoo shop in Ensenada when the artists realized that I had a Jack Rudy tattoo. The owner of the shop grabbed a magnifying glass, and the entire crew took turns trying to find one imperfection in my tattoo. They couldn't!

"DRAWING IS THE HONESTY OF THE ART. THERE IS NO POSSIBILITY OF CHEATING. IT IS EITHER GOOD OR BAD."

—SALVADOR DALÍ
PEOPLE MAGAZINE
1976

Butterfly tattoo design, done at age sixteen.

YOU SHOOK ME ALL NIGHT LONG

Once I hit my nineteenth birthday, I jumped around between a few shops, never leaving on bad terms. After Blue Bird Tattoo, I worked for the first time next to a female tattoo artist, Jen McLellan, at Red Hot Tattoo, her shop in Arcadia. Jen was seriously bad ass. Married to an old-school punk rocker, and always sporting a different Day-Glo shade on her pixie haircut, Jen had carved out her place in the tattoo world and she owned it very proudly.

Late one night while I was holding down the fort solo, tattooing a random walk-in, a very tall stranger walked in with a beautiful, equally tall blonde. I was instantly fascinated. He had a closely shaven head and his hands and throat were tattooed. His vintage black horn-rimmed glasses had lenses as thick as Coke bottles, and they magnified his Norwegian blue eyes into oceans.

"I'm Kore Flatmo," said the stranger. "Hey, I've got some flash for you to look at. Before you say no, check out my portfolio so you know I'm a legit tattooer."

Then he showed me the most breathtaking portrait I had ever seen in my life. The tattoo was of the late Sharon Tate, the actress who was murdered in 1969 by Charlie Manson while she was pregnant. Kore had framed the delicate portrait with bold Japanese-style, black-and-gray finger waves, combining the two polar opposite styles of tattooing.

All of a sudden, the little tribal sun I was doing on my client seemed so first grade in comparison.

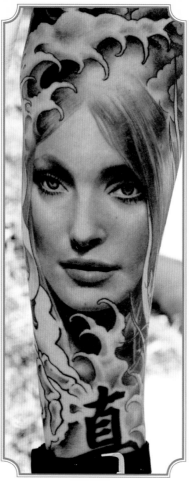

Kore Flatmo's portrait of Sharon Tate.

"I need to get tattooed by you," I finally said. I must have purchased five sets of whatever tattoo designs he was selling. I didn't care. All I could think about was what it would take to get tattooed by Kore Flatmo.

It took a few years of e-mailing back and forth and playing phone tag before we finally connected. Kore was visiting family near Pasadena and working at one of our neighboring shops. I finally got tattooed by Kore at Incognito Tattoo in Pasadena.

When Kore talked about his love for tattooing, it was electrifying. It was like he had stepped into my skin and told me why I felt the way I did. By the end of our session, I realized that he was my new mentor and hero, and in the time since, he has proven himself to be one of my only true friends in tattooing. Throughout all my years spent in the tattoo world, there has not been one tattooer who I look up to and wish I could be like more than this man.

Several years ago, Kore approached me with the idea of tattooing him. I couldn't do it. I'll tell you: I've tattooed some of my favorite bands and musicians, songwriters, authors, comedians, painters, and celebrities. No one intimidates me. I am always confident that I can tackle whatever project it is I choose to take on, but tattooing Kore feels different—the intimidation factor with him is so gnarly that I know it would affect my tattooing, and there's no way I could deal with that. To this day, I still have not tattooed him.

LOVE
at FIRST FEEL

orking at Red Hot Tattoo only lasted a little bit less than a year before I transferred to Affliction, a shop nearby. Jen understood my hunger to grow and off I went again. The roster of tattooers working there was far too talented to pass up the opportunity. I worked next to Jim Miner, Daniel Albrigo, Wendy Ramirez, and guest artists I admired, like Adam Barton.

During this time I started getting pretty serious about my tattoo machine collection. My collection had grown to over twenty custom-made machines by one of the industry's best-known tattoo machine builders, Dan Dringenberg. I was extremely tight with Dan and his wife, Jazmin, and would hang out with them six days of the week. One night, I went out to meet them at Eric Maaske's Classic Tattoo in Fullerton. They were selling tattoo machines there. When I showed up, Dan and Jazmin were chatting with a tattooer named Oliver Peck whose name I'd heard but had never formally met. He spoke with a lisp and had a toothpick in his mouth at all times. His long hair resembled a style a skater from the 70s would rock. His southern drawl was thick, and last but not least, he wore red shoes. I found out later that he always wore red shoes.

Usually I wear high heels—I'm a big fan of platforms. But, for some reason, that night I'd busted out my old-school red Pumas. It was a fateful decision. Oliver instantly noticed my red sneakers and struck up a conversation with me, and we really connected. We started dating immediately, and it didn't take long for us to make it official. Two months after we met, we eloped to Vegas and got married at the Little White Wedding Chapel, right off the strip. It was March 8, 2004, which also happened to be my birthday. I returned to Los Angeles the next day as a twenty-two-year-old newlywed.

Some of our friends were happy for us, but most were shocked. I knew spilling the beans to my dad was going to be a tricky one, and when I mustered up the courage to tell him three days later, I got the reaction I was expecting. Disappointment.

"This is the biggest mistake you have ever made!" he told me. "You are destined to divorce, and Oliver is a coward for not asking me for your hand in marriage!"

He said he wouldn't come to our reception the following week, and I cried.

But even though he disagreed with my decision, my dad came through. I was happy and surprised when he showed up at the reception, and I knew he would come to accept Oliver in time.

Oliver was a big name in the tattoo world. Our styles were radically different, practically polar opposites. I did fine-line black and gray. He did bold line, traditional full-color 1950s-style work. I learned a lot about color from him.

A seventh-generation, full-blooded Texan, he lived in Dallas in his screen-printing warehouse. Shortly after we married, we bought a house in Dallas, near White Rock Lake. I began splitting my time between Texas and California, spending two weeks in L.A. and two weeks in Dallas.

Because of the constant commuting, I needed to work at a shop in Los Angeles that wouldn't mind my on-again, off-again schedule. That's when I made the move to Clay Decker's True Tattoo in Hollywood. Clay was putting a super crew together, and he wanted me on board at his shop.

I was finally at the point in my career where I felt that my peers were starting to fully respect me as an artist.

Have a Drink on Me

Clay Decker is a household name in Los Angeles when it comes to tattooing. He gained his reputation from his impeccable Japanese style of tattooing, along with his strong use of color. All the respect is very well deserved.

I had met Clay only once, some time back at the Dringenbergs' house. Now he was moving True Tattoo from its original location on Santa Monica Boulevard to Cahuenga Boulevard, near the Hollywood Walk of Fame. The grand re-opening of True Tattoo had the tattoo community buzzing. This was big, exciting news. The team of tattooers Clay had put together was practically a dream team— Chris Garver, Tim Hendricks, Daniel Albrigo, Dan Dringenberg, and Rick Clayton were among the artists. The other local shops were pissed off at the idea of such a powerful crew of tattooers working in the neighborhood.

True Tattoo was where I officially met Chris Garver. During my first week working there, he was off to Miami to film some kind of TV show about tattooing. It was a documentary-style program that showed the dynamic between artists and clients. Throughout the tattoo process, viewers would learn the story behind each of the tattoos.

Once tattooers got wind of the show, the hating began.

There had been much talk among tattooers about the negative effects of having a televised tattoo show and what it would do to the business. Everyone was treating tattooing as if it were some kind of secret society. No one wanted to give up any tricks of the trade, and they focused their animosity on the artists in those shows. Of course, some of these concerns were valid—it was important for the right people to be on air representing the professionalism of the tattoo world. But in my opinion, for a lot of the disgruntled tattooers, it was more about jealousy and their own insecurities.

Tattooing in Hollywood was different than anywhere else I had worked. Dave's tattoo shop, with its down-and-out clients, felt like it was a million miles away. True Tattoo was its complete opposite. Centered in one of the liveliest hot spots in the city, the neighboring hangouts were Hollywood's favorites. Once the sun went down, the beautiful people of Tinseltown stirred, ready to party.

To our right were the Beauty Bar, Tokyo, Tiny's, Star Shoes, Cinespace, and the King King. To our left were the Velvet Margarita, Citizen Smith, and Big Wang's. Directly across: the Burgundy Room, Hotel Café, and Zao. In every direction you could find an A-list of clubs that catered to the red carpet crowd, all just a drunk stumbling distance away from the shop.

Tattooing all the local bartenders didn't help if you weren't looking to party. And I was. I would tattoo from noon to 10:00 at night, and then we would go out. Mondays, we'd go to the Rainbow on Sunset and then hit the Key Club for Metal Skool; Tuesdays, we'd work our way up and down Cahuenga Boulevard. Wednesdays were for Dragonfly, Thursday was a repeat of Tuesday, and Fridays and Saturdays we liked to see bands. On Sunday, the Spazzmatics played on Santa Monica Boulevard. On Monday, we'd start again.

I was having such a great time in Hollywood that trekking back to Dallas to see Oliver starting getting old. I found myself avoiding that commute as much as possible, preferring when Oliver spent more time with me in L.A. I was still partying, and even though Oliver had been sober for over thirteen years, he was supportive of my routine. He would often volunteer to be my designated driver, and he never really held it against me when I would inevitably be hung over the next morning.

Hell Ain't a Bad Place to Be

Along with the bartenders, I was tattooing a lot of musicians, including some of my favorite artists. I had tattooed almost every member of HIM, one of my favorite rock bands from Finland. They had come to town to record the album *Love Metal,* and the lead singer, Ville Valo, was searching for a tattoo artist. Ville and I were introduced by Rane, a mutual friend and a member of the Finnish rock band Smack.

Ville was looking to cover up an old lover's initial, which he had tattooed around his nipple. We agreed that HIM's heartagram logo would do the job, and the cover-up was a smashing success!

A line drawing of Ville's cover-up tattoo.

We all quickly became good friends, and once the album was complete, HIM returned to Finland, leaving me with an open invitation to come and visit. I took them up on their offer. I went to Helsinki with no idea that I was about to fall in love—with a country. I made it an annual trip from then on.

My friend Jen Z came with me. We planned on going for several weeks, just the two of us. I packed all my tattoo gear and we set off, primed for a quality summer vacation.

Six days into our trip, I got a call from Chris Garver.

"The network wants to add a girl to the show here in Miami, and we all agree we want you," he said.

I had no intention of leaving Helsinki. And I didn't like the thought of abruptly embarking on a filming schedule that would require me to stay in Florida for a long stretch. I had never been to Miami, and balancing my time between L.A. and Dallas was already hard enough.

After much discussion with Oliver, and my boss, Clay, we came to the conclusion that whether or not I agreed to do it, the network was going to recruit a female tattooer. And who knew whom they'd find?

I kept saying, "What if they hire a girl who totally sucks?" It wouldn't be the first time you saw a talentless chick on TV who got picked up based on looks alone, and the thought of an inexperienced female tattooer misrepresenting everything I had been working so hard for made me sick to my stomach. When I agreed to the gig, it wasn't about being on television or in the spotlight. It was about stepping up to represent tattooing in the right light. The whole thing happened practically overnight, and the next few days went by in a blur. My flight arrangements were changed quickly, and I was scheduled to land in Florida the following day. I was greeted at the Miami airport by a few people from the production crew, and the sound guy rushed to wire me with a mic. The cameras rolled, documenting my every move and twitch, from picking up my luggage and getting in a cab to arriving on set at the South Beach shop.

The crew would have followed me into the bathroom if I had let them. But I soon got used to being filmed—I was more comfortable than I had expected! John Austin, the head sound engineer for *Miami Ink,* and later for *LA Ink,* still likes to tell people, "Kat doesn't turn her mic off when she pees."

It helped that everyone on set was very welcoming, especially the production crew. I walked around shaking everyone's hands and tried my best to remember their names! I must have met a hundred people that morning.

The shop was small. I was used to working at True Tattoo, where we had a plush drawing station, and I had my own private tattoo station on the second floor where I tattooed right next to Clay. I was starting to miss home, but I shook the feeling off and tried my hardest to focus on my new surroundings.

The daily routine of the show made everything work like clockwork, and I got into the swing of things. We were filmed from 9 A.M. to 9 P.M., five days a week. We would go in and do anywhere from one to three tattoos a day on camera. It was so time-consuming! After we were finished tattooing, we were interviewed on camera about our experiences with the clients—it was cool to have a visual diary of how I had spent my day.

Off camera, Oliver and I were working to stay as close as possible. It wasn't easy. He had been working the Warped Tour, the traveling music and skateboard festival, touring all over the U.S. with his tattoo equipment. We made arrangements to meet up at least once a month; filming and working took up the rest of my time. I didn't want to neglect my clients and peers back home in Hollywood, so I found myself flying out to L.A. on the weekends, and flying back to Miami in time to start filming on Monday morning.

In the beginning, the show felt on, and I felt welcome. But after a while, things changed. There were tensions that hadn't previously existed, and I kept thinking that Ami, the shop owner, resented me because he had to share the attention. Some people really like the spotlight! My biggest complaint was that I like to tattoo every day, and I was only allowed in the shop when we were filming. Owner's rules! This wrought havoc on my own tattoo schedule as I had to scramble for places to work comfortably when the cameras weren't rolling.

After two years of this, my schedule was wearing me down. This was not a great time for me. I was over

> "The women around Ami tend to be very complacent, so when Kat wasn't, it was like 'Uh oh…'"
> —John Austin, head sound engineer for *Miami Ink* and *LA Ink*

worked and exhausted, and my marriage was suffering. I never got to see my family. I didn't have time in Miami to make new friends. Whatever downtime I had, I spent staring at the walls of the apartment that the production company had set up for me. I felt really alone.

Meanwhile, the show wasn't really feeling like it was worth all of the effort. Things on the set were not going smoothly. There were disagreements, and a lot of people who didn't see eye to eye.

When I was approached with the idea of a spin-off set in Los Angeles, my home, I was ecstatic. We were in talks with the network for months before everything was set in stone, and unfortunately, not everyone was as stoked about the idea of me having my own show, let alone with a similar format to *Miami Ink*'s. Friction between some of the other cast members and me grew like an infection. The number one rule was that we couldn't discuss the idea of there being a show while we were on camera because it broke the feeling of reality. So there were definitely things happening behind the scenes that didn't come across on television. Most people didn't know how tough things really were. And many were quick to judge anyway. But some viewers sensed the tension and emailed me about it—even Dolly Parton.

> "Now, I don't mean to rile you or bring you down, because I think you are a sweet girl, honestly. Just when I was starting to like the show and the beautiful art, I'm finding myself disappointed in two very beautiful artists. I was starting to become a fan, but this is really making me sick."
> —Dolly Parton

I knew it was time to head back home and focus on things that were more important, like spending time with my family. At the same time, I knew there was a lot of hard work ahead of me. I was about to start a new show, build my own shop—this was a crazy time for me.

While the contracts were being drawn up for my new show, I was busy playing catch-up not only with my family, but with clients. By this time, Oliver and I had separated, and we started legal proceedings for our divorce. It was a very difficult time in my life. But along with all of the heartache came new reasons to be happy.

�֎ ✖ ✖

LA INK was a positive new beginning. The next thing I knew, all the contracts were signed, and it was time to build my own little empire. The construction of High Voltage Tattoo had begun, and I was ready to start a new tattoo family. Finding artists to work with was a lot easier than dealing with the construction, but in the end, it was all worth it.

I got to put together an all-star team, and my mission was to find the best tattooers to be on the show with me. That's how I met Hannah Aitchison and Kim Saigh. I flew out to Chicago to ask them to join me, and when they said yes, everything started to come together. I've looked up to Corey Miller since I was sixteen years old, and when he agreed to be on the show, I was really stoked. Things were falling into place.

PART 11

LET THERE BE ROCK

HIGH VOLTAGE TATTOO

{
"IF AC/DC OPENED UP A BEAUTY PARLOR,
IT WOULD BE HIGH VOLTAGE."
—CHARLIE PAULSON,
GUITARIST *for the band* GOLDFINGER
}

Deciding on a name for your business can be as difficult as finding the perfect name for your band—or maybe even your child! But naming my shop High Voltage Tattoo wasn't that hard for me, considering I'm a firm believer that music and tattooing go hand in hand. When I envisioned my tattoo shop, I was thinking pure rock 'n' roll—and the band AC/DC was definitely in the back of my mind. The AC/DC logo is simple, iconic, and really eye-catching—both the font itself and the red-and-yellow color scheme—and I pretty much modeled the storefront after it.

That was pretty much my vision for *LA Ink,* too. I wanted the vibe of the show to be really fun and upbeat, and I wanted viewers to be wowed. I wanted to show the diversity of Los Angeles with all it has to offer—and I wanted to push the envelope when it came to tattoo skills. The artists on the show are incredible, and the elaborate tattoos they did on the program are a reflection of that.

Whether I was thinking about High Voltage or *LA Ink,* I wanted to steer away from a traditional tattoo shop vibe with the old tattoo flash designs crudely hung up on the walls. I'm a big fan of that look, and it does belong in a shop, but I wanted to do something different. I'm a workaholic, and I knew I'd be spending the majority of my life in my shop, so it was important to me to create an environment that was a bit more stylish and elaborate, somewhere that would feel like home to me. So you won't find many tattoo-related pieces of art on the walls at High Voltage, not because I dislike them, but because the shop is an extension of me. On the walls are all the things in my life that have influenced me not only as an artist but also as an individual.

Riffing off the AC/DC logo, I began by giving everything at High Voltage a red-and-yellow lightning bolt theme. The floors are candy-apple red enamel, with a yellow lightning bolt, and the drawers all have custom-made lightning bolt handles. The logo also inspired the lightning bolt tattoo on my face.

The first thing you see when you walk into the shop is the huge, beautifully carved front desk, which we call the pirate ship. The ceilings are high, and a rich red chandelier drips with crystals and figures of Jesus.

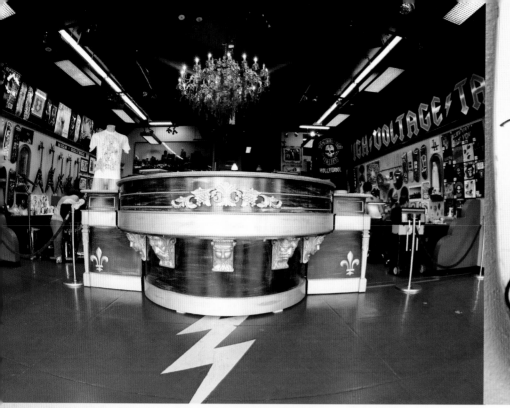

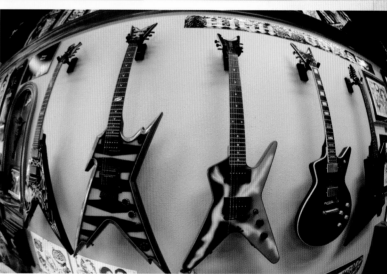

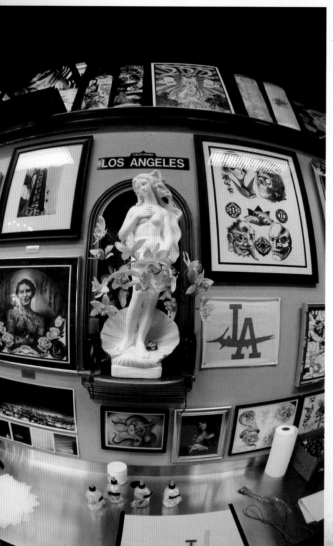

CLOCKWISE FROM TOP LEFT:

· Welcome to High Voltage!
· Human organ sculptures by California artist Sonya Palencia.
· This is an original, signed watercolor by Kore Flatmo
 that he gave to me when I opened High Voltage.
· I bought the Jesus chandelier from New Orleans
 designer Mitchell Gaudet.
· The front of the shop.
· Tony Hawk's personal skateboard, signed by him.
· Guitars donated by Slayer, Pantera, Fireball Ministry, & Atreyu.
· LA Ink tattoo artist Corey Miller's station.

Every place you look there's something else to wonder at: From the stripper pole to the red brocade curtains with tassels like the stage curtain at L.A.'s old Orpheum Theatre, from the Guns N' Roses pinball machine to the neon green "fig leaf" that somebody has thoughtfully added to cover the crotch of the male mannequin showing off a High Voltage sweatshirt. Baroque-inspired frames on all the original artwork and larger-than-life photo light boxes—the size of those enormous framed movie posters in theater lobbies—show all walks of life in the tattoo world.

I've been collecting old-school skateboard decks, mostly signed by the pro skaters I've tattooed over the years, as well as random rock memorabilia like guitars, drum heads, cymbals and sticks, posters, and records autographed and given to me as gifts by musicians that I've worked on. I also have paintings and sculptures from artists all over the world. I knew I would most likely be adding to those collections over time, so I've made them a part of the shop, too. When you walk into High Voltage, you walk into my living room, the place I live with my family.

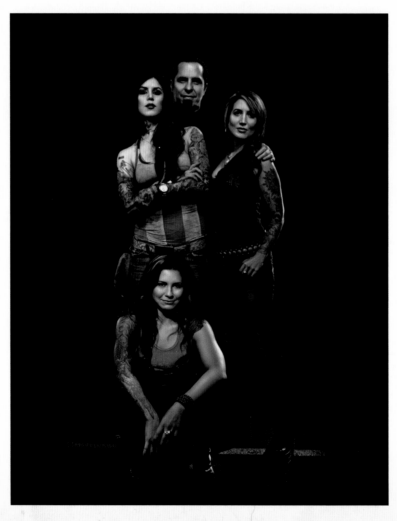

Me and the LA INK crew, clockwise from top:
me, Corey Miller, Hannah Aitchison, and Kim Saigh.

First Blood: My Tattoo Family

must admit I have a hard time agreeing when people say hiring friends and family is a bad idea. There's no one on this planet I trust more than those people. Sure, sometimes it can be difficult to separate the business and personal sides of a relationship, but in this business, I couldn't have someone working for me whom I didn't trust 100 percent.

For me, the crew at High Voltage Tattoo is my tattoo family. High Voltage is made up of a team of tattooers, shop managers, merchandise managers, assistants, online moderators, janitors, and one handy man, all of whom I consider dear friends. And all of the people who helped to make the shop what it is are in my tattoo family, like Factory 311, who painted the awesome mural of the cast and one of my hairless cats, Ludwig, out back.

Because *LA Ink* is filmed at High Voltage, some folks assume that the only people who work here are the cast you see on TV. But there are a lot of pivotal characters who don't get screen time, and without them, the shop couldn't run. Our shop and merchandise managers include G-Spot, Adrienne Ironside, Baxter Paulson, Jez, and Raymond Herold. You'll meet some of them later in these pages and get to see the amazing tattoos that they have collected. And aside from the artists on *LA Ink* — Hannah Aitchison, Kim Saigh, Corey Miller, and me — we've got our beloved B-team crew of tattooers: Dennis Halbritter, Mojo Foster, Nate Fierro, Adam Forman, Khoi Nguyen, Adrian Gallegos, and Jeff Ward. By the way, they dubbed *themselves* the B-team. These guys are always making fun of themselves, but in truth they are all wonderful artists whose work speaks for itself.

I put together this crew of people for a reason. It doesn't matter who you are and what you want when you walk in here, somebody is going to do whatever style tattoo you're looking for. We're a well-rounded group. Dennis does amazing bold color. Mojo does really intense portraits. Khoi does the most perfect, immaculate tiny tattoos I've ever seen, among other things, they're like stickers. And Nate is the youngest of the crew. He's like our little baby boy, you know? Dennis took him under his wing, and he's growing so crazy fast. It's incredible.

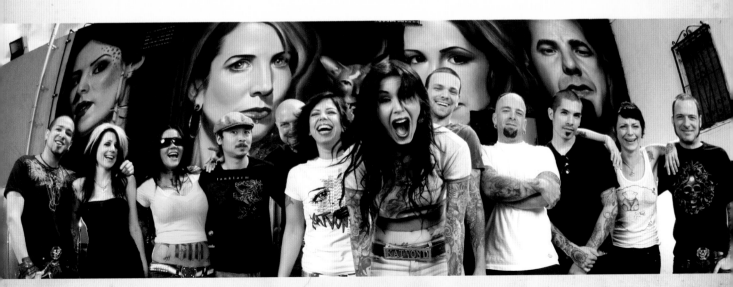

The crew: left to right: Adrian, Baxter, Jezebel, Khoi, Mojo, Karoline, me, Jeff, Rob, Nate, Adrienne, and Dennis. Not pictured: Adam, G-Spot, and Raymond.

The B-Team

The people working with me at High Voltage are amazing artists—and great people. They jokingly call themselves the B-team, but as you can see here, their work is A-list.

Tattoo by KHOI NGUYEN

Tattoo by DENNIS HALBRITTER

Tattoo by JEFF WARD

Tattoo by **MOJO FOSTER**

Tattoo by **ADAM FORMAN**

Tattoo by **NATE FIERRO**

WELCOME TO
MY SANCTUARY

My office is my sanctuary. It's one of the few places where I can really focus on my work and feel completely at home. I have everything I need there: my piano and my personal library of reference books, which range from *Tom of Finland*—which I got for a guy who wanted a sleeve of gay porn—to a massive edition of *Gray's Anatomy,* books of pinup queens, and an anthology of Edgar Allen Poe's stories.

Photographs, letters, and mementos cover the walls, from a black-and-white 70s porn photo of my friend Alana's mother (you'll hear more about her later) to a sepia-toned image of a smug young boy smoking a cigarette who would grow up to receive a life sentence in prison. I'm going to get that photo tattooed one day.

KAT VON DJ

{ MY PLAYLIST }

When I'm working in my sanctuary, the right tunes set the right tone. Here's what's cranking on my stereo from dawn 'til dusk, from my top songs to my favorite bands. Along with regular orders of pizza (hold the basil), this is the music that keeps me inspired when we're going past hour three...

FAVORITE SONGS

Song	Artist
"Right Here In My Arms"	*HIM*
"L' Via L' Viaquez"	*The Mars Volta*
"Pray For Me"	*Sixx A.M.*
"Painted By Numbers"	*The Sounds*
"D.I.B. (Drenched in Blood)"	*Turbonegro*
"Enemy in Me"	*Vains of Jenna*
"Come Back"	*Josh Rouse*
Sonata "Pathétique"	*Ludwig van Beethoven*
"Hurt Me"	*Wynona Carr*
"Whore Hoppin'"	*Eagles of Death Metal*

And the rest of my favorites (There are so many great songs, it's hard to pick!)

CLASSICS
Guns N' Roses
Mötley Crüe
Judas Priest
Motorhead
AC/DC
T. Rex
The Stooges
Thin Lizzy
ZZ Top
Black Sabbath
Alice Cooper

METAL
Slayer
Children of Bodom
Mastadon
In Flames
DimmuBorgir
Dark Tranquility
Cradle of Filth
Arch Enemy

SOUNDTRACKS
The Devil's Rejects
Romeo & Juliet (1996)
Just Friends
Saturday Night Fever

MELLOW
Concrete Blonde
Morrissey
Neil Young
Starflyer 59
South
Sparklehorse

1950s
Ruth Brown
Little Richard
The Calvanes
Roy Brown
Nappy Brown
Louis Jordan

TECHNO-ISH
Kylie Mynogue
The Faint
Fischerspooner
Massive Attack
Telepopmusik

LATIN
Selena
Beny Moré
Perez Prado
Xavier Cugat
Yma Sumac
Vicente Fernandez

RANDOM FAVORITES
Heavens
Kill Hannah
Fireball Ministry
Steel Panther
Omar A. Rodriguez
The Libertines
Sunny Day Real Estate
Bigelf
Curtis Mayfield
The 69 Eyes
John Frusciante
KENT
And anything
Linda Perry gets
involved with

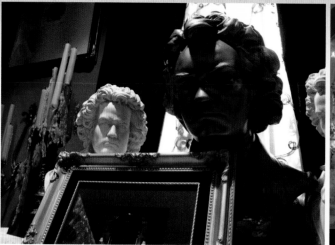

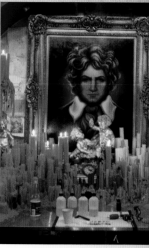

My library: Reference books are a tattooer's best friend.

I received this bust of Beethoven from a client as a gift.

My station: This is where the magic happens.

My sanctuary is full of memories—mine and those of strangers—and a lot of them come in the mail. Since most people don't write letters anymore because they are too busy texting, the letters I get are usually from little kids or people in jail. That's a pretty amazing span. But I get the most letters from people in jail, because they have all the time in the world. They tell me their names and why they're in prison, and that they didn't commit the crime. And that they're going to be in jail for a long time. So they reach out and tell me that they appreciate my art, and they share their art with me. Some of them draw these crazy, super-elaborate pieces. It's pretty fucking awesome.

From the High Voltage mailbag: "Dear Kat, What can I say, just a young outlaw heathen grin, when I was about five years old. Respectfully, James, a Southern Kid." This image is going to be added to my tattoo directory one day.

I tattoo in my office on a bright yellow massage table that also serves as a desk for my writing and art projects when there is nobody stretched out on it waiting for me to create art on their shoulders, backs, or stomachs. Actually, my office is a place to socialize, too. All of my friends know that I'm constantly working, so clients will drop by to let me know how they're doing, my boyfriend will come by to give me a kiss and make sure I've had lunch, or my fellow tattooers will knock on the door so that they can introduce me to their mother. And my two cats, Ludwig and Agatha, have the run of the place while I work.

I've paid a lot of attention to the vibe in my office, and I've worked pretty damn hard to ensure that almost everything in my sanctuary—aside from my tattooing equipment and electronics, which are state-of-the-art—is pre-twentieth century. Ludwig van Beethoven is the inspiration behind all of this. It's the hopeless romantic in me. His portrait hangs on the wall over a wall-length worktable, surrounded by hundreds of half-burned red and white candles.

My office is private and intimate, and it makes me feel safe. The entire front of the shop can be pumping loud rock 'n' roll, with the hustle and bustle of tourists, clients, and all other walks of life going in and out, but in my sanctuary it's calm and peaceful.

Home sweet home.

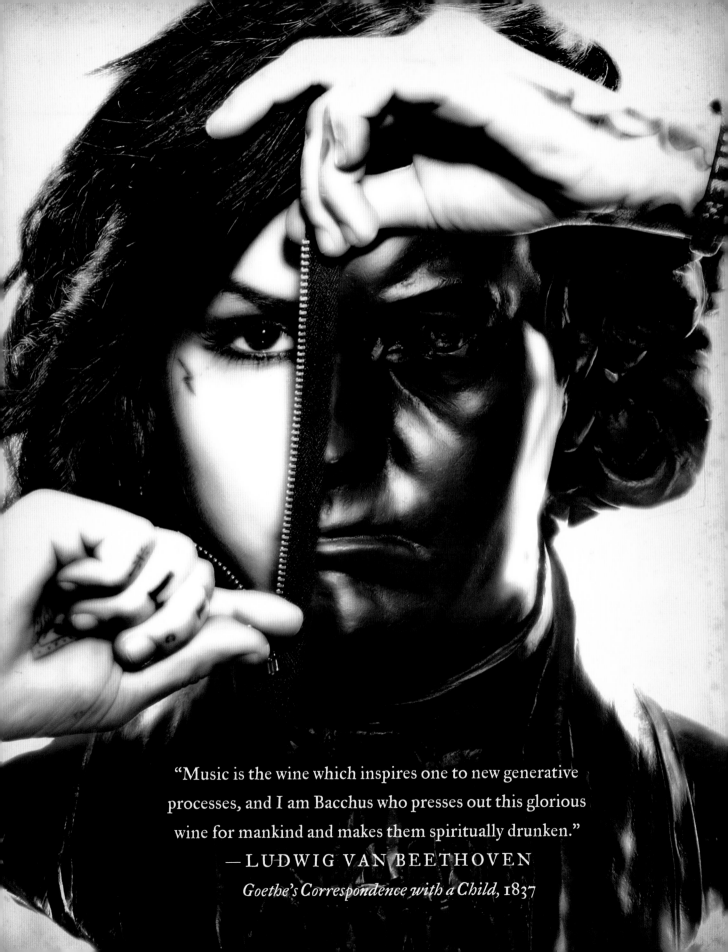

"Music is the wine which inspires one to new generative processes, and I am Bacchus who presses out this glorious wine for mankind and makes them spiritually drunken."
—LUDWIG VAN BEETHOVEN
Goethe's Correspondence with a Child, 1837

Live Wire: My Artwork

I was never formally trained in the fine arts. I learned to draw in a raw style, with my fingers or whatever was around me instead of with proper tools and technique. Now, as long as I have a mechanical pencil and some copy paper lying around, I am good to go wherever I am.

I do a lot of sketches on paper with graphite. Here are some recent drawings.

Agatha Blois.

I did this sketch on an airplane.

My friend Rhian, graphite on paper.

Linda Perry.

STRIP CLUBS
My 1951 Chevy
FINLAND
MEXICO
THE 1800S
ANTIQUES
FASHION
CHOLOISM
Old Hollywood
PHOTOGRAPHY
DEATH
THE FOUR AGREEMENTS
AGATHA BLOIS
Writing
MY FAMILY
Being a hopeless Romantic
CUTTHROAT CAREER WOMEN

HAIRLESS SPHYNX CATS
Red Lipstick
Harpsichords & Pianos
Scandinavian Metal
PEANUT BUTTER ANYTHING
BEING SOBER
Los Angeles
{ BOOKS TRUE LOVE MUSIC }
Foreign languages & Accents
Long Walks on Sunset Strip
ODD NERDRUM
Bikers * The F word
BEETHOVEN'S LOVE LETTERS TO HIS IMMORTAL BELOVED
STEAK
Long-haired Rocker Boys
CLOWN-INFLUENCED ART & POP CULTURE KITSCH

I'VE ALWAYS LIKE TO COLLECT THINGS—
I JUST CAN'T HELP IT!
THE HUMAN MIND LOVES REPETITION,
AND I AM NO EXCEPTION.

ROSARIES

PLATFORM SHOES

PIANOS

All Things Beethoven

{ Paraphernalia related to the
INDEPENDENT ORDER of
ODD FELLOWS,
especially
The REBEKAHS }

MID-1950S R&B & DOO-WOP RECORDS

{ RARE }

OLD-SCHOOL SKATEBOARDS

MOURNING JEWELRY

{FOUND} POLAROIDS

LETTERS FROM THOSE IN JAIL

ART MY FANS SEND ME

CONCERT TICKET STUBS

SKELETON KEYS

Designer Sunglasses

LEG WARMERS

SCARVES

BELT BUCKLES

Feather Quill Pens

ANTIQUE JOURNALS

SETTING A GUINNESS BOOK WORLD RECORD

On December 14, 2007, I set the Guinness World Record for doing the most tattoos in a twenty-four-hour period. People don't always realize how much of a group effort it was—more than fifty people, including my sister, Karoline, worked together to coordinate the whole thing. By the end of the day, I had tattooed an L.A. symbol on four hundred arms, backs, and legs (and a few behinds). I did one tattoo every three to five minutes. This is not a working schedule that I would recommend!

I work with a charity organization called Vitamin Angels that supplies essential vitamins to children in third-world countries. Their goal is to stop child blindness by 2020. The way the program works, twenty dollars can help eighty kids. By the time we were done with all the tattoos, we had collectively saved over 32,000 kids from going blind. In our minds, that was the real record.

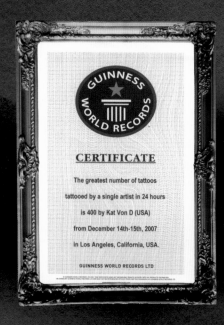

GUINNESS
WORLD RECORDS

CERTIFICATE

The greatest number of tattoos

tattooed by a single artist in 24 hours

is 400 by Kat Von D (USA)

from December 14th-15th, 2007

in Los Angeles, California, USA.

GUINNESS WORLD RECORDS LTD

TATTOO

DIRECTORY

Here it is—the ultimate guide to what I've got where. And how! I think there are too many to count, with many more to come as soon as I can sit still long enough. I'm going to have a full body suit one day.

UNDER MY CHIN

I used to drink a lot of tequila. So I got this tattoo to give people something to look at when I was taking shots!

Flower

MY NECK

Roses

When I got the black-and-gray roses on the side of my neck, my main goal was for the rose buds to reach across the front of my throat. Eventually, I think I'll have something similar done on the other side.

ABOVE MY LEFT KNEE

Skull

This Kore Flatmo design was taken from one of his sets of flash and done by yours truly at the age of nineteen. I had to do this one upside down.

David Letterman

I got this caricature just moments before going on David Letterman's show with the hopes of surprising him, and boy did I!

666

Scott Ian of Anthrax and a big crew showed up to the shop around 1:00 A.M., after a Van Halen rehearsal, and we all got this tattoo. Scott got it on his finger, Pearl Aday got it behind her ear, Kirk Hammett from Metallica got it on his ass, and so on. Scott tattooed mine.

MY HEAD

On June 6, 2006, I was in Miami and I got this tattooed on the back of my head. It's tiny, about the size of a dime. We had to shave a chunk of my hair off in order to do it. No one can see it, but I like knowing it's there.

MY FACE

Stars

These stars are one of my favorite tattoos. Originally, I had only one on each of my temples. Throughout the years, I've added a few more here and there. When I was married, my husband told me to stop getting my face tattooed, and being the stubborn person I am, right then and there I went and added seven more stars!

Tim Miner giving me my first star tattoos when I was twenty-one.

MY EYELID

Stars

I have two stars on my left eyelid that aren't usually visible because of my eye shadow. One of my dear friends from back in the day had one on his eyelid and we wanted to match, so he tattooed two on me. We no longer speak, but the tattoos are a memory of our friendship as it was.

BEHIND MY EARS

13

One Friday the thirteenth in Texas, Oliver Peck added this gem to my right earlobe.

On a different date, a very long time ago, my friend Jazmin and I both got cartilage tattoos. She got pink hearts and I got black stars. The most annoying part wasn't the pain but the noise from the machine lingering so close to my ear.

TCB

This is tucked behind my ear and stands for "Takin' Care of Business" in a flash! Daniel Albrigo was the artist.

INSIDE MY LIP

"Truth"

I was fifteen years old when I got that. It is a constant reminder to keep my words honest.

MY STOMACH

"Hollywood"

In "red lipstick." This one was inspired by one of my all time favorite glitter rock bands, the

TOP OF LEFT LEG

Fan and cherry blossoms

This Japanese-ish style tattoo on my thigh was done by Juan Puente at Spotlight Tattoo. We still haven't finished it.

THE OTHER SIDE OF MY LEFT KNEE

Skull

This is my very first skull tattoo. Ron Earhart, who is famous for his biomechanical style, did this sugar skull, an imitation of the candy skulls sold in Mexico on the Day of the Dead, during the Boston tattoo convention, the first year tattooing became legalized in Massachusetts.

Yearbook leg

From the knee down, I've allowed a lot of my nonartist friends to tattoo me, hence the term "yearbook leg."

"Ryan was here!"—Ryan Dunn.

Buff n Stuff—pro BMXer Mike "Rooftop" Escamilla.

ZZ—Done in Philly at Bam Margera's pre-wedding bash at the hotel. We forgot the wire that plugs into the power supply, so we had no electricity. Jim Rota of Fireball Ministry hand-poked that one as we were listening to ZZ Top.

"Dreamseller"—Brandon Novac did that one the same night. It's the title of his book.

High Voltage—Bam did that one (drunk off his rocker).

"I heart Suomi?"—that is, "I love Finland." Got that one in Helsinki on my first trip to Finland.

"Joser"—by José Pasillas of Incubus. He was going through some tough times. He had a few drinks, tattooed this on me, and felt a whole lot better.

WTF—Not surprisingly, this stands for "What the fuck?" Derek, the drummer of Bleeding Through and a childhood friend, did this one in Dallas while the band was on tour. Each band member got this tattooed that night.

DIB—"Drenched in Blood" is one of my fave Turbonegro songs—and I'm sure it was playing at the time.

Repiola—In 2007, I flew my mom out to the Monterrey tattoo convention. At my booth, in front of thousands of people, I asked her to tattoo me. She finally agreed and did one of the best "nontattooer" tattoos I have so far. The word repiola is Argentinian slang that loosely translates to "real cool." It's my mom's fave word: She has it on her license plate, she named her coffee shop in Mexico Repiola—and then she got to write it on my leg.

Way cool weekdays—Colin Dowling, a fellow tattooer, came up with this gem on a drunken whim. I am told it was a Monday, hence the way cool weekdays.

Bookworm!—I tattooed this onto Bam's knuckles, then he and his wife Missy returned the favor.

INSIDE OF RIGHT BICEP

Rosa Carmina

Rosa Carmina (below, left) was a Mexican actress from 1950s. I am so enamored by the golden decade of cinema in Mexico that I wanted Rosa in my collection. Pete Castro tattooed this.

Skull with hat

Jackass's Steve-O thought that if he licked my arm the stencil for the tattoo (below, center) would stick to it. Jeez!

Rose background

I added the realistic roses (below, right) later as background to connect most of the tattoos.

RIBS ON MY LEFT SIDE

Angel of death

A single-needle, black-and-gray angel with a biker-inspired simple shading in the background throwing up the horns! Yeah!

MY LEFT ARM

Los Angeles lettering

This was done by Juan Puente at Spotlight Tattoo.

Black-and-gray roses, traditional-style

Juan Puente did this after spending over six sessions doing laser tattoo removal treatments on the tattoo of the New York Dolls pinups that I had gotten when I was fifteen years old. Finally, it lightened enough to cover. Thanks, Juan!

Karoline

This black-and-gray portrait of my sis, Karoline, was my first forearm tattoo. I got it when I was eighteen from Pete Castro while I was working with him at Blue Bird. It was outlined with a single needle.

INSIDE MY LEFT BICEP

1942 Varga Girl

This was my first black-and-gray, portrait-style, single-needle tattoo. This is what sparked my love for fine-line black and gray. Pete Castro spent a total of six hours on that one.

VON LEFT

MY RIGHT LEG

Ludwig van Beethoven

The particular portrait of Beethoven reminds me of Tom Hanks, for some reason. The Zombie version of Beethoven was done by Robert Hernandez from Spain. I still can't believe he did that freehand.

Snowflake

Jim Miner did this design. It has a heartagram in the center, and it isn't finished. It hurts so bad to tattoo the side of your knee cap!

Tongolele, Maria Victoria, and Columba Dominguez

From my shins down, it's all 1950s Mexican movie starlets. You can see Columba Dominguez in detail on the next page.

THE INSIDE OF MY LEFT THIGH

Cartoon character

Scott Harrison tattooed this black-and-gray egghead cartoon-type character with big floppy boobs, a rat tail, and crow feet holding a martini glass.

MY LEFT KNEE CAP

"True"

Clay Decker tattooed this word down my shin as kind of a "going away" present when I decided to open up my own shop. He tattooed the solid color design in a fast forty-five minutes!

Black-and-gray shield #10

Corey Miller gave this tattoo to me on my ten-year anniversary of tattooing. I could barely sit for it, but he did an amazing job. Mind you, the entire thing is lined and shaded with a single needle!

MY RIGHT ARM

Billy the Butcher

Nikki Sixx and I got this matching tattoo from Thomas Hooper at New York Adorned; we borrowed the logo from a doily we found at the Bowery, one of our favorite hotels in New York City.

"I Love You," by Nikki

I said to Nikki, "Write me a love letter, babe," and this is what I got.

Pinup holding tattoo machine

Pete Castro gave me this pinup when I was eighteen. It took eight fucking hours, which is the longest I've ever sat. I do not recommend sitting for more than three to four hours at a time.

Woman's face

The face at the top of my forearm was done by Jack Rudy at Tattooland in Anaheim.

MY WRISTS

Black-and-red, traditionally styled renditions of my brother and sister on each wrist have the Spanish words *hermana* (sister) and *hermano* (brother) lettered above each caricature.

Portrait of my father

Black-and-gray portrait of my father, Rene Von D, in a high-school photo taken in Argentina in the 1960s. I'm totally enamored with the tie. Obviously, this one is my dad's favorite!

RIB CAGE

Girl and L.A. skyline

I originally wanted a Latina-style girl with the L.A. skyline in the background, but the artist who did had a different interpretation of the idea. This just looks like just another pinup tattoo, but I still like it. I never did finish the skyline though.

MY RIGHT HIP

"City of Angels"

This is one of my many L.A.-inspired tattoos.

VON RIGHT

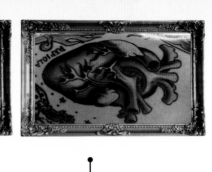

BACK OF MY LEFT THIGH

This is by far the most painful tattoo I have evergotten. The crease where your leg meets your ass is famous for being extremely painful—ask anyone with a bodysuit. As far as I know, that tattoo isn't going to get much further along than the outline that it is. I'm sure I can just live with it unfinished.

BACK OF MY LEFT CALF

Heart

Juan Puente did this full-color, anatomically correct heart while he was working at Shamrock Tattoo on Sunset Boulevard.

MY LEFT ANKLE

J

My first tattoo! Still there! I'll never cover it up. It stands for James, my first love when I was fourteen years old. It was done with a homemade rig in some punk rocker's dirty living room.

Piano with skull

Daniel Albrigo gave me this piano, and the letters *LVB* were inscribed for Ludwig van Beethoven.

THE BASE OF MY NECK AND BACK

Carmen Miranda

I'm a big fan of her music, but mainly idolize her for popularizing the platform shoe in America in the 1940s. Pete Castro tattooed this.

Mi Vida Loca

Spanish for "my crazy life." This is taken from the cholo culture of East L.A. I got it on Cinco de Mayo in 2004—after I drank a bottle of tequila.

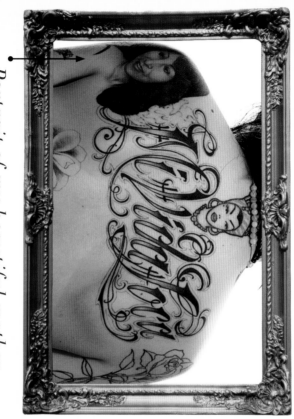

Portrait of my beautiful mother

This black-and-gray portrait of my mother, Silvia Von D, is based on a photo taken by my dad just before they got married. I had to steal it from my mom in order to tattoo it! She knew why I wanted to borrow it, and back then, she was so against tattoos. A day before her birthday, when I was twenty-three, I took it when she wasn't looking and did the deed. At her birthday dinner, I handed her photo as a gift. When she asked me why I was giving it back, I told her I didn't need it anymore and showed her the tattoo. She totally freaked out. It's her favorite tattoo now. She makes me show it to all of her friends.

Outline of white flower

This was the first tattoo I got after I went sober, so this one really hurt! I could only sit for Dennis Halbritter for about half an hour, so hopefully next session we will bust it out!

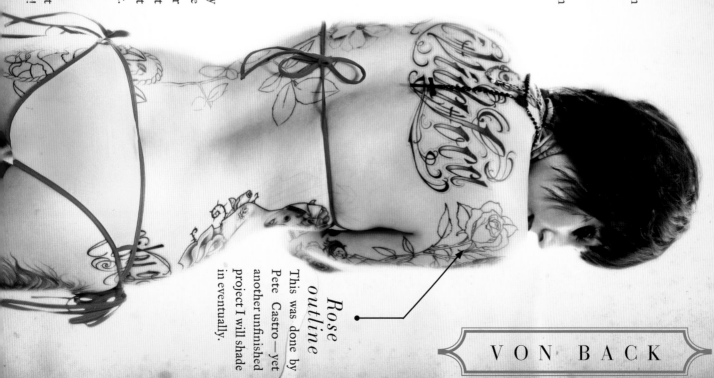

Rose outline

This was done by Pete Castro—yet another unfinished project I will shade in eventually.

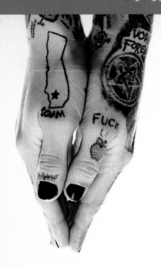

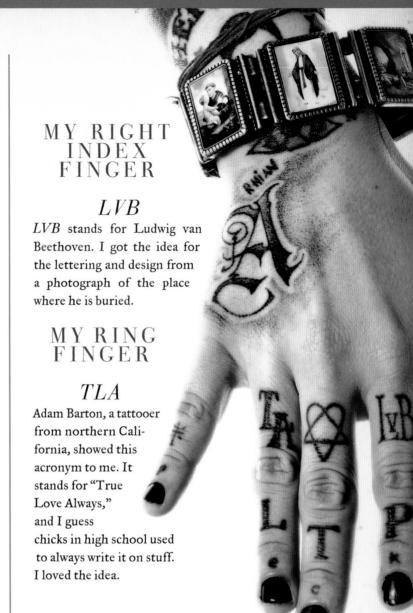

MY RIGHT INDEX FINGER

LVB

LVB stands for Ludwig van Beethoven. I got the idea for the lettering and design from a photograph of the place where he is buried.

MY RING FINGER

TLA

Adam Barton, a tattooer from northern California, showed this acronym to me. It stands for "True Love Always," and I guess chicks in high school used to always write it on stuff. I loved the idea.

MY RIGHT THUMB

LAMF

The old Johnny Thunders–inspired acronym for "Like A Mother Fucker." That tattoo hurt like one!

California

Above *LAMF* I have the outline of the state of California, with a star placed where L.A. is.

MY LEFT THUMB

"Fuck You"

My hot momma friend Agatha Blois, who makes all my leather clothing, tattooed "Fuck You" on my thumb one day. I love this tattoo so much because it was given to me by a dear friend.

Apple

The little red apple was the result of drunken whim. My ex, Oliver Peck, did it on the same night he did the tattoos on my middle finger.

MY RIGHT PINKY

Pachuco cross

This cross tattoo is popular among the cholos.

ABOVE MY KNUCKLES

LTP

"Love The Profession." A few tattooers have this tattooed; I also have *LTP* inscribed on a few of my tattoo machines.

MY RIGHT PALM

Heart

Done by Oliver Peck in Dallas.

VON HANDS

TOP OF MY LEFT HAND

All-seeing eye

Kore Flatmo did the eye engulfed in ribbon. I was supposed to get both hands matching that day, but I'm such a wuss I couldn't hang!

MY LEFT INDEX FINGER

Spider

The spider with a heart was done by Jeff Rassier from Blackheart Tattoo. We were wasted and tattooed each other. He tattooed me perfectly, but you should see the one he has. Sorry, Jeff!

K

A few years ago, Karoline and I got matching *K* tattoos at a tattoo convention in Southern California. I got mine on my left index finger and she got hers on her left arm. Oliver Peck did it for us. This one hurt like a bitch!

THE SIDE OF MY RIGHT HAND

DILLIGAF

MY MIDDLE FINGER

Heartagram, lightning bolt

Oliver Peck tattooed a heart on both of my middle fingers, but a lightning bolt just on this one.

MY LEFT RING FINGER

L.A. sign

The sign stands for Los Angeles. Your ring finger connects to your heart; I put the tattoo here because what's more appropriate than the city I'm married to?

MY LEFT PINKY

13

Nearly all my "13" tattoos were done by Oliver Peck on various Fridays the thirteenth. (I've got seven altogether.) He was obsessed with that date; in 1999, he offered 13 tattoos for 13 bucks in an attempt to set the Guinness World Record for the most tattoos in a twenty-four-hour period at his shop, Elm Street Tattoo, in Dallas. He did 320 tattoos of the number 13 that day—and he is the originator of the idea! To this day, every Friday the 13th he does little tattoos of the number 13 for 13 bucks. I know, because he is the most competitive person ever, that he is the one who is going to beat the world record I set in 2007.

Star

The little Star on my pinky was my first ever finger tattoo by Tom Tilden.

The motto of my life: "Does It Look Like I Give A Fuck?" It's an old acronym first adopted in the early 1900s by sailors and later embraced by biker gangs in the 70s.

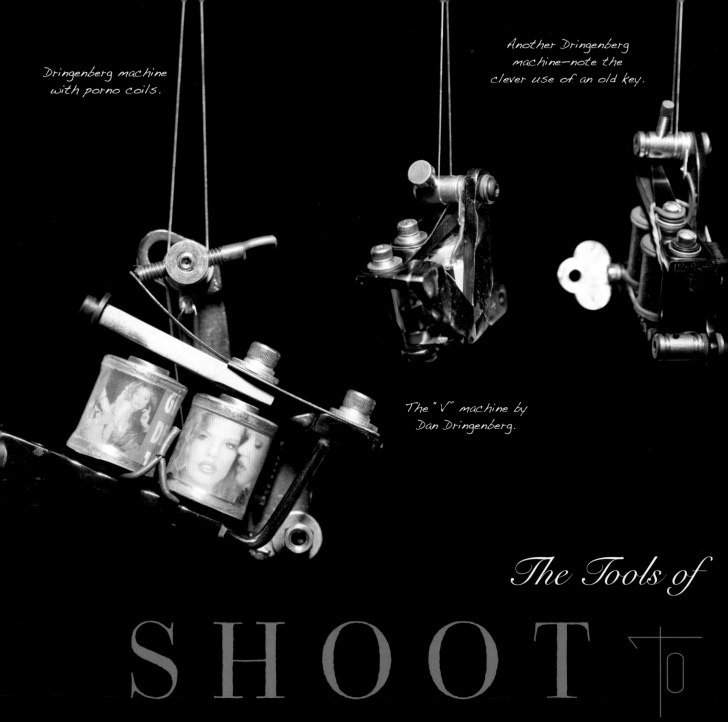

Dringenberg machine with porno coils.

Another Dringenberg machine—note the clever use of an old key.

The "V" machine by Dan Dringenberg.

The Tools of
SHOOT ⸸

IN 1876, Thomas Edison filed a patent for an "improvement in autographic printing." His improved pen used a needle to pierce paper, creating a stencil that could be used for printing. Fifteen years later, a tattoo artist in New York realized that Edison's ideas could be used to create a tattoo machine. Samuel F. O'Reilly filed his own patent in 1891 for what he called, simply, Tattooing-Machine. He added more needles and an ink reservoir, and the future of tattooing suddenly looked a whole lot brighter.

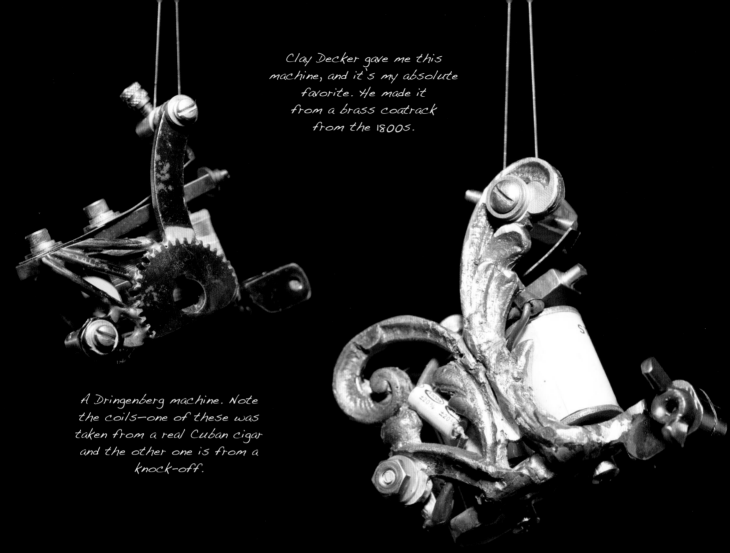

Clay Decker gave me this machine, and it's my absolute favorite. He made it from a brass coatrack from the 1800s.

A Dringenberg machine. Note the coils—one of these was taken from a real Cuban cigar and the other one is from a knock-off.

the Trade

THRILL

{ "My invention relates to a tattooing-machine, the peculiar and novel construction

of which is pointed out in the following specifications and claims . . ." }

—SAMUEL F. O'REILLY, TATTOO ARTIST, 1891

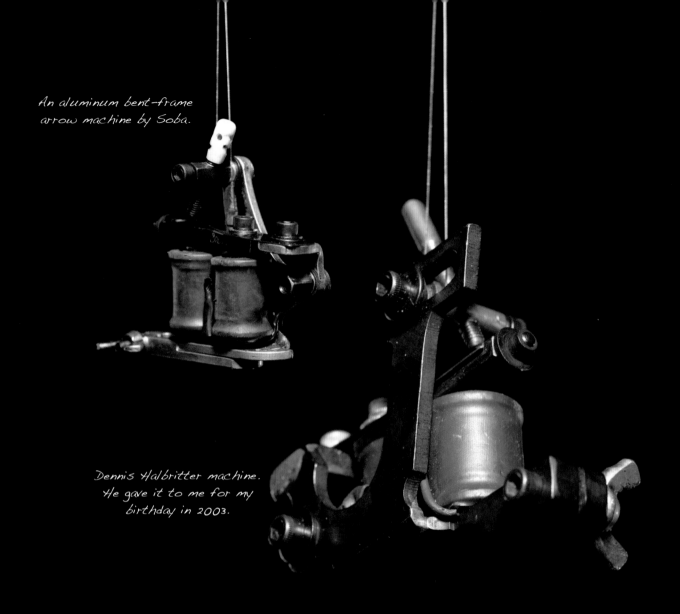

An aluminum bent-frame
arrow machine by Soba.

Dennis Halbritter machine.
He gave it to me for my
birthday in 2003.

The tattoo machine is one of the simplest mechanical devices ever invented. It works just like an old doorbell, relying on electric magnetization. Basically, the electricity causes the needles to pierce your skin, and the gravity causes the ink to enter your skin. When the machine is connected to a power source, the electromagnetic coils push the armature bar on the machine downward. The needle (or needles) are connected to the armature, so when it's drawn down by the magnetic coils, the needles are pushed into the skin. The needles rest inside a tube, which has a small well at the tip. When the needle enters the skin, the ink penetrates, and the tattoo artist can begin creating the tattoo.

Tattoos are made of lines and shading, so there are two complementary types of tattoo machines: liner machines and shader machines. Much like the different brushes of a painter, a tattoo artist relies on the different machines to achieve myriad effects. A liner machine is used to outline the tattoo, and its mechanism allows the artist to draw a solid, crisp line. When the artist wants a softer effect, he will turn to a shader machine. A shader

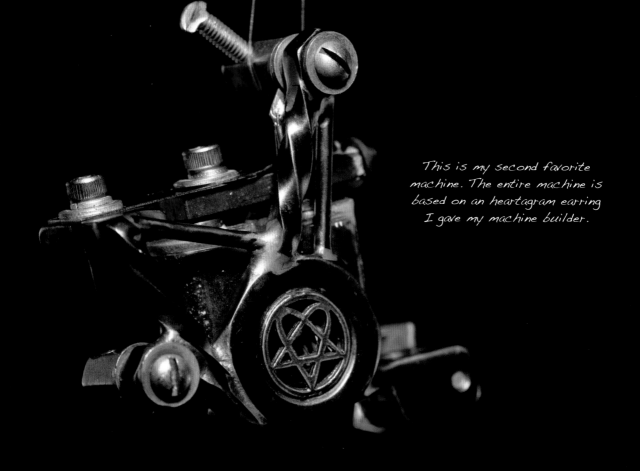

This is my second favorite machine. The entire machine is based on an heartagram earring I gave my machine builder.

machine has a longer stroke than the liner machine, and the needle hits a little harder. This allows the artist to move the machine at a much quicker pace, creating a "peppering" effect that allows the artist to blend colors or gray washes easily.

During my years tattooing, I've accumulated over fifty machines because there's a certain tool for each job. The more experienced an artist is, the more he will understand the full range of artistic possibility when it comes to using the tattoo machines. Some people tattoo fast, some people tattoo slow. Some are heavy-handed, some have a lighter touch. In the end, it doesn't matter as long as the tattoo looks good.

There has been a rise in the number of tattoo machine makers in the past ten years, with a lot of tattooers wanting to craft their own tools. In my opinion, there are a handful of machine makers who stand above the rest and set standards for the industry today: Aaron Cain, Dan Dringenberg, Juan Puente, and a few others. I asked Dan who he thought was incredible, and he added a few names to the roster: Clay Decker, Scott Sylvia, and Pote Seyler.

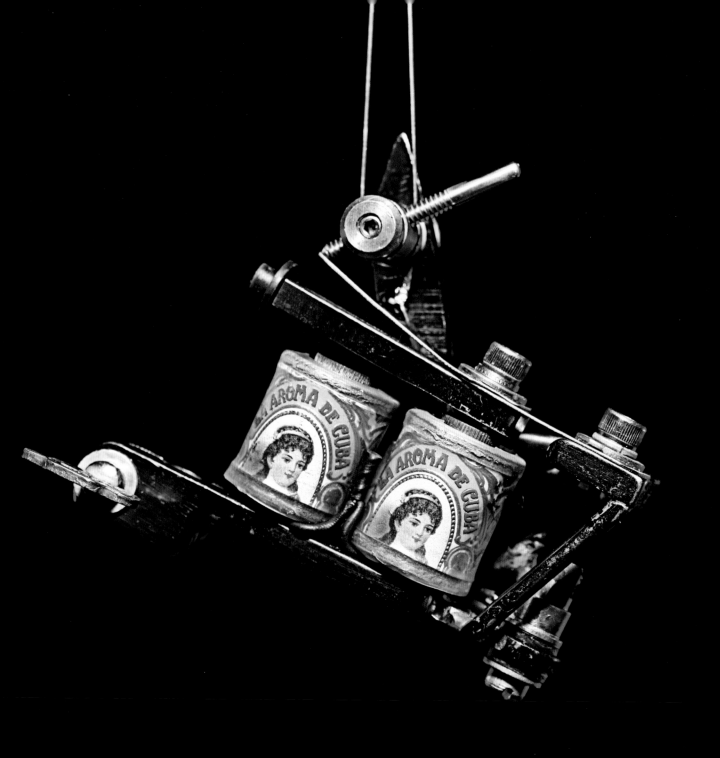

Another Dringenberg masterpiece, made
from a railroad spike from the 1800s
with an overlaid gold "L.A".

Most machine makers craft their designs to work as tools that will provide reliable performance and never fail. Some artists craft them to work like pack mules as well as being visually pleasing. Tattoo machines are commonly made out of steel, brass, iron, or aluminum. Electricity conducts at the highest levels with silver, steel, gold, and iron, but obviously precious metals would make tattoo machines very costly.

I've always been a very visually oriented person. I appreciate beauty. I pay attention to details. Everything in the shop is strategically placed to showcase religious, musical, and artistic motifs. So when it came to designing my own tattoo machine, I had to push the envelope.

The most important thing to me was that my tattoo machine run exceptionally well and be beautiful. When I was eighteen, I went to the Milan Tattoo Convention, and there was an artist who had a tattoo machine from an underground Russian machine builder. The machine was made out of gold and looked like the petals of roses. It was incredible, very elaborate—but it was way too heavy. It didn't run well. It looked cool but it wasn't functional. And I believe you can have the best of both worlds. Another inspiration for my tattoo machine was my collection of skeleton keys. They're so intricate: I love looking at them and knowing that somebody took the time and love to put in all the little engraving. And that's what I wanted for my machine. I wanted it to have a refined, delicate quality but function like a top-of-the-line Porsche.

So I asked Dennis Halbritter, who works with me at High Voltage and is an amazing tattoo machine maker, to work with me to make the Kat Von D Machine collection, which includes a shader and a liner. Our collaboration sparked him to rethink his old ways of designing and manufacturing a traditional tattoo machine. I wanted something that would be aesthetically mind-blowing and artistically impeccable. I wanted to create a piece of art that could be used to make incredible tattoos. Dennis approached his friends at Han Cholo in Los Angeles. Han Cholo partners Brandon Schoolhouse and Guillaume Pajolec are master jewelers who make the coolest rock 'n' roll-meets-Star Wars-inspired pieces. They really get my vibe, and we knew they could help make my vision for my machine a reality.

Dennis Halbritter's mock-up for the Kat Von D machine thumbscrews.

Mock-ups by Dennis Halbritter for the Kat Von D shader machine.

MUSINK

usink was an idea that came to me during the filming of *LA Ink*, and it turned into a three-day festival that combined my two biggest obsessions in one event: music and tattooing. (It's probably obvious, but the name comes from combining the words "music" and "ink.") With the help of my good friend Bill Hardie, we had both sides covered.

My job was to put together a well-rounded group — about two hundred — of some of the best tattooers from all over the world. They would tattoo the public while Bill compiled an amazing lineup of rock 'n' roll bands to perform. Even though it sounds like a lot of fun (and it was!), it was also a lot more work than I thought it would be. Wrangling travel arrangements for two hundred tattooers, plus keeping track of paperwork, booth arrangements, and setup was pretty time-consuming — not to mention booking my favorite, rockingest bands during one of the most popular touring seasons.

Once we got the bands together, which took a lot of coordinating, I started to have the thought we all have before big parties we're hosting: "What if no one shows up?"

Man, was I wrong! We sold out every night. The place was packed with all walks of life, everyone from punk rock kids to soccer moms. We all had a really good time, getting tattooed and then rocking out into the evening with some of the raddest bands around:

Steel Panther, Fireball Ministry, Vains of Jenna, Tiger Army, Guana Bats, Throw Rag, The Used, The Invisible Humans, and Revolution Mother.

Musink ended up being quite a success. You could walk down the aisle of each tattoo booth and see tattoo styles from all over the world. In one aisle you saw Jack Rudy, Juan Puente, Kore Flatmo, Luke Atkinson, and Clay Decker, while just down the row and around the corner, you'd see the crew from High Voltage, Six Feet Under, Horitaka, Bob Tyrrell, Nikko Hurtado, Jack Mosher, as well as tattooers from Germany, France, England, Japan, Hawaii, Mexico, South America — and everywhere else in between.

We had tattoo contests every day, handing out trophies to the winners of the best black-and-gray tattoo, best portrait, best back piece, best sleeves, and even weirdest tattoo. And anyone who had gotten their tattoo within twenty-four hours of the contest was eligible for "tattoo of the day." Educational tattoo seminars were also held by highly respected tattooers. Hannah Aitchison showed tattooers how to hone their pinup skills and world-renowned artist Shawn Barber demonstrated how to paint portraits. Bob Tyrrell had tips on black-and-gray tattooing and portraits, and Tony Olivas did a seminar on how to tune your tattoo machines.

We got such great reviews that we're taking Musink on the road as a tour across the United States.

Sink the Pink: Black and Gray versus Color

Many people think I dislike doing color, only because the majority of tattoos I'm featured doing on *LA Ink* have been grayscale portrait-style tattoos. Sometimes I feel like I get pigeon-holed with the whole "she only does portraits" thing. I enjoy doing color, although I prefer black-and-gray tattoos, because they feel more realistic to me. I love putting a realistic twist on almost anything I do—even in color!

One of my favorite clients, Joe Ortiz, has been collecting pieces from me for several years. He's always eager to get tattooed and will make the drive from northern California to L.A., even on very short notice. Besides being a great client, he's a pleasure to work on for several reasons. Not only does he have great skin, he sits well and can handle a lengthy session.

Even though Joe always comes prepared with plenty of reference material to make sure we are on the same page, he keeps an open mind when I pitch ideas. Some people find it hard to use their imagination when an artist presents a vision, but Joe understands that the tattoo will come out best when the artist is given creative freedom. That's another reason I love to work with him.

Frida Kahlo in black and gray.

Recently, I was able to tattoo two portraits of Frida Kahlo on Joe—one in black and gray, and the other in full color. It's interesting to see the difference in style, and how color can totally change the vibe of a tattoo. It's mostly about your personal aesthetic. In this case, the portraits of Frida look great in either style.

Color tattoos can look absolutely incredible, but the tricky part with color portraits—and this is why not many people do it—is that if you don't use the colors correctly, you can make the image look cartoony. Some artists, like Nikko Hurtado, have perfected the use of color to a point that is unbelievable.

Even though lots of tattoos look good both ways, black and gray is classical and timeless, like an old photograph. It looks realistic—always my goal. And it resonates for me, because I grew up in Southern California, where black and gray is so prominent with the cholos, the gangsters, and in jailhouse tattooing, because prisoners don't have access to much color. Black and gray has both an elegance and a rawness that I find appealing, especially when it comes to portraits.

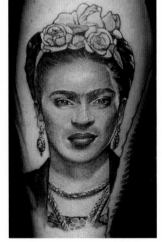

Frida Kahlo in color.

Frida looks beautiful in either color or in black-and-gray, but the black-and-gray version reads like a shock to the system. She looks so lifelike, so elegant—this is something I strive for in all the portraits I do, whether I'm creating a tattoo of someone famous or dear to the heart.

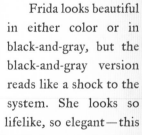

"The only consideration in choosing between black-and-gray and color is personal preference, because most of the time, when a tattoo is executed correctly, an image can translate well in both mediums. When it comes to black-and-gray versus color tattoos, I break the tattoo process down the same. It all has to do with value and color choices."

—NIKKO HURTADO, TATTOO ARTIST

TATTOO SHOP DOS AND DONTS

DO	DON'T
The correct terms, if you want to be taken seriously, are "tattoos," "tattoo machine," "tattoo shop," "tattooing," and "tattoo artist."	Those in the know don't say "tats," "ink," "ink work," "gun," "tattoo parlor," "slinging," and "inkslinger."
Bring in examples of the things you vibe on so that the tattoo artist can get an idea of your personal aesthetic. There's nothing more fun for an artist than being given creative direction that allows for customization and artistic freedom.	Bring in photos of other people's tattoos that you would like to mimic, particularly celebrity copycats. There's nothing more annoying than being asked to do another one like Pam Anderson's barbed-wire armband.
Test the waters first with a less obtrusive location.	Get your first tattoo on your face, hands, or neck.
Go to a professional tattoo shop.	Go to a tattoo party to get a tattoo.

CARING *for* YOUR TATTOO

It seems like every artist says something different when it comes to tattoo aftercare. The truth is, your body will heal regardless of what magic potion you apply to your fresh tattoo. But listen to your artist's advice on aftercare to guarantee a faster healing time and to keep the chance of an infection to a minimum.

Infections are rare, but when they happen, they suck! An infection is one of the few things that can truly screw up your tattoo. So listen to your artist's instructions for an easy healing process and a perfect tattoo.

This is how I personally take care of my tattoos:

✳ Keep the bandage on the tattoo for at least two hours after the work is complete (or longer, depending on the tattoo artist's instructions).

✳ Remove the bandage very carefully and throw it away. This allows your skin to breathe and begin the healing process.

✳ Put a drop of mild antibacterial soap on your hand and lightly wash the tattoo. Gently pat it dry with a washcloth (not a paper towel), taking care not to rub it.

✳ Massage a thin coat of the healing ointment recommended by your artist over your tattoo. Continue to do this for the first few days, then switch to a plain skin lotion that is free of dye, perfume, lanolin, vitamin E, aloe, or alcohol.

✳ Avoid getting a lot of water on your new tattoo—showers are okay, but don't go swimming or take baths for a few weeks.

✳ Keep your tattoo out of the sun. If you must tan, wait two weeks, then always apply an SPF 50 product.

✳ Do not pick or scratch your new tattoo. This can cause permanent damage.

✳ Do not let other people touch your tattoo as it is healing.

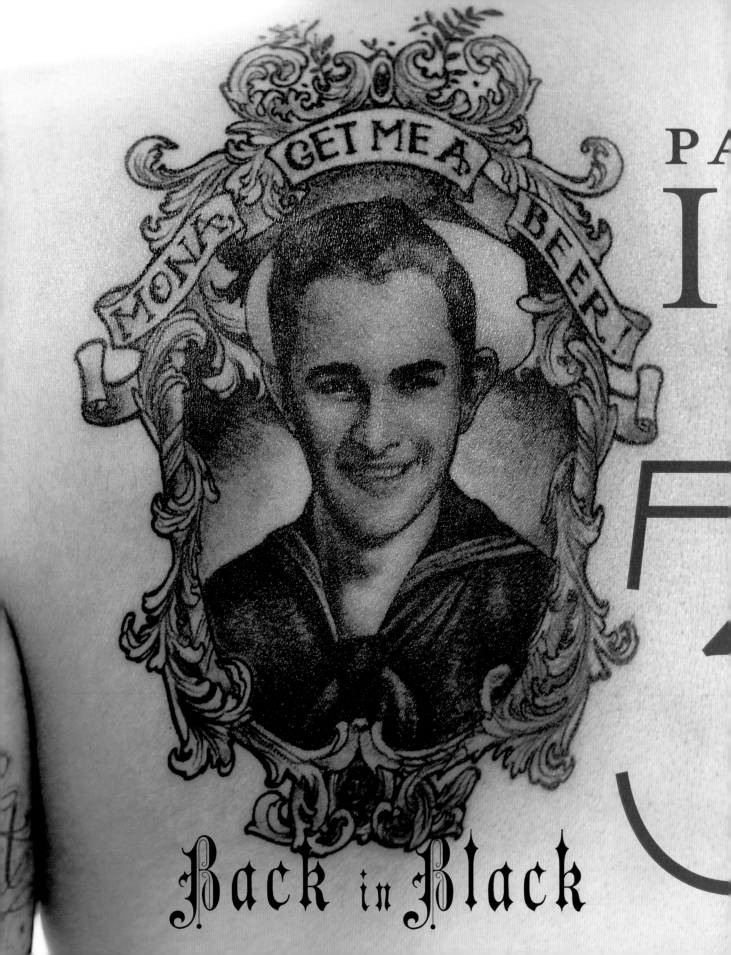

GET IT YOURSELF!

Portraits

Who Made Who: Family Portraits

In early portraiture, mainly royalty and nobility had their portraits painted. That all changed during the Renaissance, when portrait painting as an art form exploded. The best-known portrait in the world is probably da Vinci's *Mona Lisa*, and I have seen this tattoo on more than one person. That's the power of art: a woman that history would have forgotten is now an icon, one of the most familiar faces in the world.

For me, the power of portraits comes from their realism; ever since I started sketching people's faces when I was a child, I have been obsessed with crafting the most realistic renditions possible. People really respond to that commitment: They come to me when they want to show somebody how much they love them or honor a treasured memory.

KAROLINE VON D: OUR LITTLE BROTHER MIKE

> "GETTING MY BROTHER'S FACE TATTOOED ON SUCH A VISIBLE PART OF MY BODY IS A WAY TO SHOW THE WORLD HOW MUCH I LOVE HIM." — KAROLINE VON DRACHENBERG

Portrait of Mike Von D.

In my family, we like to wear our hearts on our sleeves—and our shoulders. Karoline's portrait was the first family portrait I ever got, at the age of eighteen. As my first forearm tattoo, it was a pretty big deal for me, because I was committing myself to the tattoo lifestyle by getting a tattoo in such a visible location. Karoline has always been my best friend, and I assume the feeling is mutual, because a few months later, she got a matching portrait of me on her upper arm.

Karoline's tattoo of my brother was a surprise for him.

The hard part about being the only tattooer in the family is that I am the go-to girl when my parents need to blame somebody for my siblings getting tattoos. From an early age, my younger brother, Mike, begged me to tattoo him, and I constantly turned him down by telling him that if he got permission from my parents I'd do it—always knowing that my parents would object. It was the same situation with my older sister, Karoline.

Once those two turned eighteen, it was over for my parents. There was no stopping Mike and Karoline from getting tattoos, especially Karoline. The day she got our little brother's face tattooed on her arm, I got the phone call from Mom. I thought she'd be used to it all by now, but I guess some things never change!

Looking back on it, Karoline says, "At first my mom was pissed when she found out I tattooed my forearm. She was so worried I wouldn't be able to find a good job, but when it came to the actual tattoo, she had to love it. I mean, it's family!"

SYLVIA VON D: EMBELLISHED LOTUS

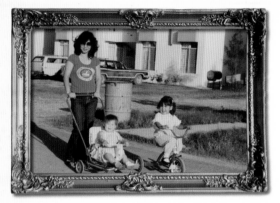

A vintage photo of Mom and her girls.

After twenty-six years of marriage, my parents decided to get a divorce. My mom knew it was time for a change, and she was finally ready to get a tattoo at the age of fifty-three. Surprisingly, she did her research and came with a bunch of reference material. Every element in her tattoo was chosen for a reason. Her pink lotus flower reflects herself blooming into a new life. The cherry blossoms represent the fast pace of life because they only bloom for a day; she got the blossoms for Karoline. She says that I'm one of the most colorful people she knows, so she picked a colorful butterfly to represent me. You can see a rising sun in the background, which represents my little brother, her baby. At the bottom, I put *KKM* for our initials: Karoline, Kat, and Mike.

Mom's tattoo.

MY FAMILY TATTOO TO-DO LIST

AS YOU'VE SEEN IN MY TATTOO DIRECTORY on page 49, I've got more than few family-related tattoos, among them my dad, my mom, my sister, my brother—even a tattoo that my mom did on me. But there are some more family-related tattoos I'd like to do.

MY FULL LAST NAME, VON DRACHENBERG

Von Drachenberg means "dragon of the mountain" or "dragon mountain." I have a few slides of my grandparents standing in front of the Schloss Drachenberg castle, which is near Königswinter, somewhere in western Germany. One day I'm going to go visit the castle that shares my name.

A PORTRAIT OF MY LIL BRO, MICHAEL

I've done my parents and my sister, and Mike is next up.

THE WORD *FAMILIA*

I've always wanted to get that word tattooed somewhere on my body. I imagine it in a fancy gangster style or Old English script.

Jim Rota

I LOVE MY FAMILY VERY MUCH, AND HAVING THEM ON ME MEANS HAVING THEM CLOSE.

—JIM ROTA

Jim's grandfather.

I MET JIM ROTA IN 2007,

at pro skater Bam Margera's wedding in Philly. An ordained minister as well as the front man for the rock 'n' roll band Fireball Ministry, Jim officiated that day. I was already a fan of Jim's music, and we talked about all things musical over a slice of wedding cake and became fast friends. When the subject is music, Jim is king. We talked about everything: the top ten worst band names ever, the best leather clothing maker, religion, good Italian food, and, most of all, the huge importance of family in our lives. Jim is part of my family now, and I was happy to work with him to get his grandpa and parents tattooed on him.

The portrait of his grandfather is on his upper arm, complete with full background. "The bridge in the back is the raised part of the West Side Highway near 131st Street and Broadway in New York City," Jim says. "My grandfather had his parking garage near there when I was growing up. He personified New York City to me. The "2906" was the address of his original garage uptown on Broadway. He was obsessed with that number his whole life and would play it in the lottery almost every day."

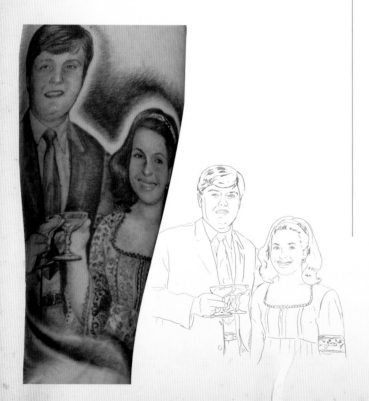

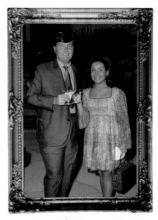

Jim's parents.

When Jim wanted to get a portrait of his mom and dad on his forearm, I was more than happy to accommodate. He showed up with one of the classiest, swankiest photos of a couple I had ever seen—it was a great image for a tattoo.

"My family is very tight. Both my parents have always been my biggest fans," Jim told me. "When my dad died, it was a huge blow. I lost him in 2004 and have always wanted a picture of him so that I can see him anytime. I chose this picture of my parents that was taken on their honeymoon. Their relationship has always been a source of inspiration for me—like a guideline of what true happiness between two people is all about."

When we were done, I couldn't wait for Jim to show his mom the finished piece. Whether you like tattoos or not, when someone gets your image tattooed properly on them, it's the most flattering compliment you could receive—and it's always fun to see their reaction. When Jim showed his mom the finished tattoo, she teased him. "Who's that hot lady on your arm, Jim?" she asked, smiling and crying at the same time.

We added the Towers of Bologna in the background later. When I asked Jim what his next tattoo would be, I assumed he planned to stick with the family theme and, like me, end up with every family member he holds dear to his heart tattooed somewhere on his body.

"My mom always draws a skull and crossbones to sign her name, so naturally I want to get that, "Jim says. "I also want to add something for my brother and sister, but I'm not sure what yet."

All I know is that it doesn't get much radder than when your mom has a skull and crossbones signature!

Kenny Fong

HIS DAUGHTER

When Kenny's daughter, Kayden, was born, he decided to let his tattoos spill over from his arms (he has full sleeves) onto his back. "She's my angel, my baby, my little girl," he explained. "She's my world."

Children tend to be receptive to tattoos, so it's not surprising that once Kayden recognized herself in the portrait, she would not stop talking about it.

The latest tattoo marks a milestone in Kenny's lifetime. And looking at Kenny's arms, which I tattooed when he wanted to memorialize his parents, was like reading a timeline of our histories. Kenny and I are like war buddies with beautiful battle scars. The tattoos we've gotten over the course of our friendship remind us of what we've shared and how we've grown.

{ "THAT'S ME!"
— KAYDEN FONG }

Kenny's daughter, Kayden, loves to show everyone her portrait.

Frank Iero

HIS GRANDFATHER

"SOME PEOPLE HAVE TO LOOK TO ACTION MOVIES OR TO SPORTS STARS FOR A HERO. I WAS LUCKY. I HAD MY GRANDFATHER. AND TO ME, HE'S MORE THAN ARNOLD SCHWARZENEGGER AND MICHAEL JORDAN COMBINED."

— FRANK IERO

Frank Iero of My Chemical Romance is a dear friend I've tattooed a few times. The second tattoo I did for him was a portrait of his grandfather, also named Frank. My friend had always said that all of his good qualities came straight from his grandpa: Frank Sr. taught him to be a man and to take care of his family. Doing this portrait was a real honor for me, considering how much I cherish close family bonds.

The photograph Frank brought me of his grandfather was so cool! It was a vintage shot of Frank Sr., then in his thirties, playing an old Ludwig drum set with old-style brocade drapery in the background. Frank's grandfather, who had wanted him to play the drums since he was born, still plays drums every weekend. Frank says that's his greatest memory of him.

The image looked like a still from an old Frank Sinatra movie—it screamed instant tattoo classic. This tattoo completes Frank's left sleeve, capping off the entire top of his arm in black and gray.

Frank lives in New Jersey, so every time I make my way to the East Coast, we try and hang. I got to meet Frank Sr.—and Frank's father for the first time when we met up in New York for a quick dinner then checked out a jazz band with his grandfather. It was such a great feeling to meet the man behind the tattoo I had spent so much time on. He was so sweet and full of life, and instantly made me feel like I was part of the family. I immediately understood why Frank wanted to get this man's portrait tattooed.

A line drawing for Frank Iero's tattoo, and Frank—with the real thing.

When Jeffree Star showed his mother this portrait of her, she cried and hugged him, saying it was the sweetest thing he could have done for her. A month later she got his name tattooed on her ankle. It was her first and only tattoo.

Joe Ortiz commemorated his love for his parents with these tattoo portraits on his forearms. Left: Portrait of Joe's mother, from a photo taken in the 60s. Her cool hairstyle made this tattoo fun for me to do. Right: Portrait of Joe Ortiz's father when he was in the service in the late 60s.

When I finally met Jeff Bloedorn's son, Jimmy Von, it was so much fun to see the matching dimples in the tattoo and on his cute little face!

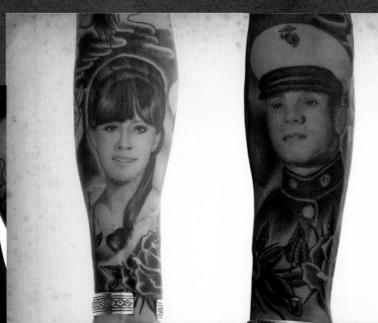

R.I.P.

(ROCK IN PEACE)

Memorial Tattoos

Tattooing emotionally charged images requires a huge exchange of energy. At first, it was difficult for me to connect with the never-ending stream of memorial portrait requests that came in during *Miami Ink*. I could feel the desperation bubbling under all of the e-mails, as if these people thought that I could alleviate their grief.

At first, I didn't understand why they imagined that I could erase their sadness. But over time, I came to understand that tattooing is a kind of therapy. I am grateful to those people who have trusted me when they felt the most vulnerable. By sharing their experiences with me, they have taught me some of my most important life lessons.

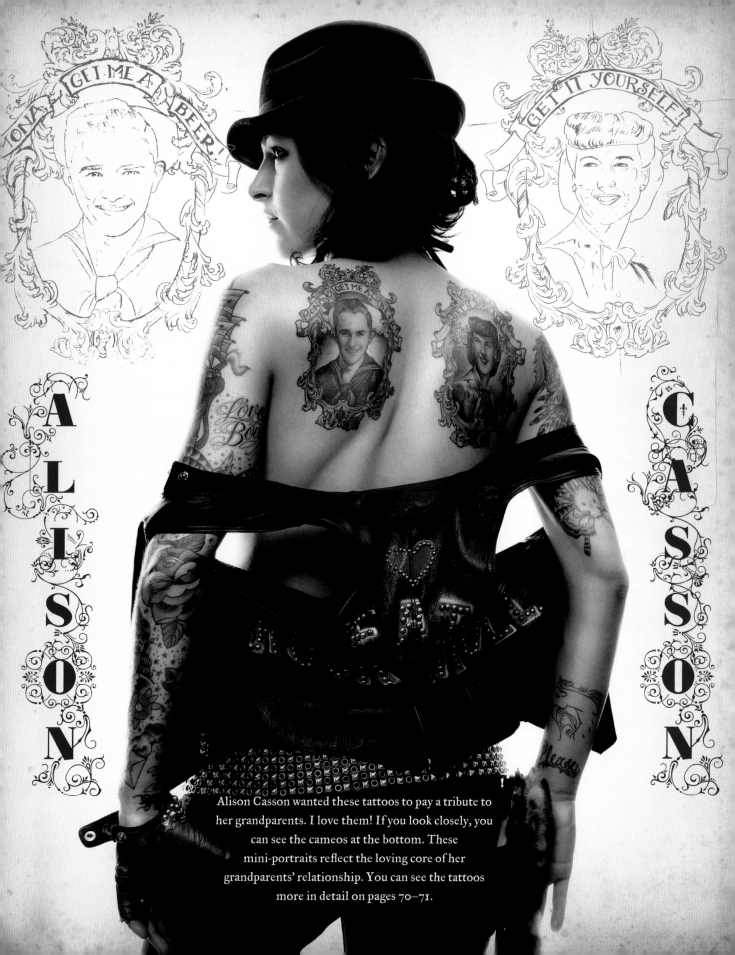

ALISON CASSON

Alison Casson wanted these tattoos to pay a tribute to her grandparents. I love them! If you look closely, you can see the cameos at the bottom. These mini-portraits reflect the loving core of her grandparents' relationship. You can see the tattoos more in detail on pages 70–71.

Frank Iero

HIS GRANDMOTHERS

"Nowadays it's hard to keep a photo album of everything that goes on in your life, so getting these tattoos are the best way for me to remember things—and it's there for the whole world to see."
—Frank Iero

When Frank married his beautiful girlfriend, Jamia, the person I most wanted to introduce Nikki to at the wedding was Frank Sr. I had loved doing that drum tattoo for Frank so much that I wanted my boyfriend to meet his supercool grandpa. I looked around the room for his familiar face and smile. Before we could reach him, a family member let us know that just two days earlier, Frank Sr.'s wife, Lillian, had passed away. I had felt a melancholy undertone to the proceedings—and now it all made sense. Nikki and I finally made our way to Frank's grandfather, offering our condolences and our congratulations.

Although there was a great sadness, Frank and Jamia's declaration of love was a beautiful affirmation of the continuation of family.

The next time I heard from Frank was after the honeymoon. He wanted to get portraits of his grandmothers, Angelina and Lillian. He e-mailed me the photographs—both women were gorgeous and took a damn good photo—and I quickly started mapping out the tattoo. We set the date for the next time he would be rolling through town.

When the newlyweds arrived, Frank had a debonair new mustache and a couple of shiners. I asked what happened, he told me he got into a fight with his mic. It was obvious that he was having a tough time dealing with the recent loss of his grandmother, and I hoped this tattoo would help him along in his emotional healing.

After tattooing people like Frank, and every other person I've tattooed memorial pieces on, I can clearly see that while I can't magically take away people's problems and pain, I can help them heal through these tattoos. And that, to me, is the best gift I could ever receive. These people are the reason I adore what I do. By sharing their experiences with me, they have taught me some of my most important life lessons.

HOW WE DID FRANK'S TATTOO

Frank already had a lot of tattoos on his right arm, so we decided to place both portraits on the top of his forearm, using lettering to separate the two faces so the end result wouldn't look like a totem pole. I created a stencil for each portrait, then mapped out the placement of the lettering so that I could draw it freehand with a pen. Frank wanted to crown his homage to his grandmothers with the words, "Forever in my Heart." Keeping the lettering simple was important; I wanted to be sure the dedication could be read clearly.

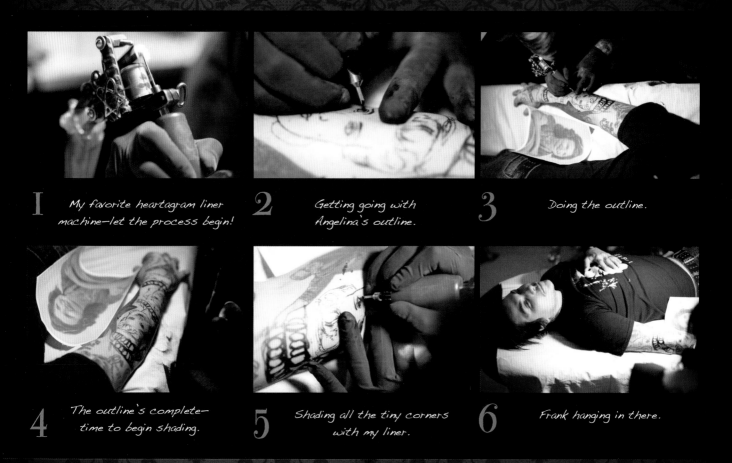

1 My favorite heartagram liner machine—let the process begin!

2 Getting going with Angelina's outline.

3 Doing the outline.

4 The outline's complete—time to begin shading.

5 Shading all the tiny corners with my liner.

6 Frank hanging in there.

Frank lay down on the bench and I began the outline, moving up towards the shoulder to avoid smearing the stencil. Instead of outlining the entire tattoo, I like to work section by section. I completed the preliminary outline of the lower portrait and then moved on to the fun part—the shading.

Shading is what gives a tattoo a soul, especially when you're masterminding a portrait. Just looking at a graphic line-contour drawing won't really show you the direction in which a tattoo will go, because it lacks the depth that black-and-gray shading gives it. But as the process moves along, you can see the shading bring the tattoo to life, giving what you're looking at a realistic fullness, so that you can see the roundness in somebody's cheeks or the shadow a nose casts, depending on the light in the image.

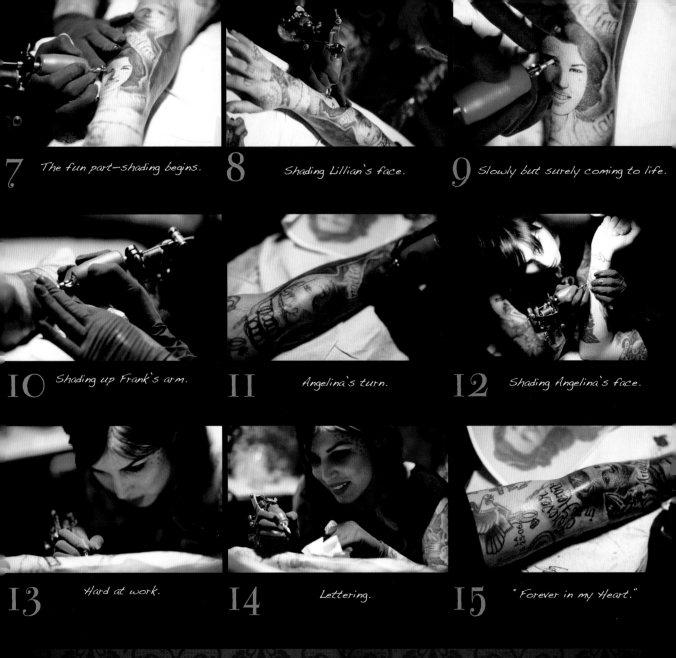

7 *The fun part—shading begins.*

8 *Shading Lillian's face.*

9 *Slowly but surely coming to life.*

10 *Shading up Frank's arm.*

11 *Angelina's turn.*

12 *Shading Angelina's face.*

13 *Hard at work.*

14 *Lettering.*

15 *"Forever in my Heart."*

Once Lillian's shading and the lettering below her face was complete, I moved up to Angelina. I finished her name and shaded her face, adding the tiny little details first and using my liner machine to get into all the wee corners that make the biggest difference, like the crease between the lips, the valley below the nose, the gradation of gray tones in the eyeballs, and the solid black of the pupils. Next up were the subtle gray tones you see in the forehead; I use a minimal amount of black in my gray wash. Every strand of hair is accounted for once the face is completely shaded out.

The last step in doing a black-and-gray tattoo is adding white highlights. This is a crucial part of the process. The tattoo looks finished, but the addition of white is what makes eyes sparkle and faces glow. Lillian and Angelina look absolutely beautiful in the tattoo, and Frank left the shop with a gleam in his eye.

16 White highlights on Lillian's lips.

17 Adding the sparkle into Lillian's eyes.

18 Moving on up to Angelina.

19 White highlights in Angelina's eyes.

20 The final wipe down—making sure I didn't miss anything.

21 Stupid ass.

22 Detail of "Forever in my Heart."

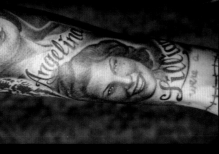

23 Lillian.

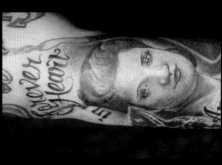

24 Angelina.

25 Frank's grandmothers complete.

26 "Lillian, Angelina, Forever or Eternally in my heart" ("forever" sounded better).

27 Two hundred cigarettes later...

This was a very meaningful tribute for Dan, whose best friend had died in a car accident. Bryce, his fiancée, and their beautiful baby daughter died together, and Dan wanted a tattoo that represented them just as he remembered them.

Dan made my job easy by bringing in a photo that was a great example of an image that translates well onto skin. It was crisp, clear, and timeless, and the couple's expressions were so honest and loving.

The fun part was that Bryce had been a tattoo aficionado, so you could see the tattoos on his body. Tattooing tattoos on a tattoo was a remarkable experience for me.

> "It's important to feel amazing about the tattoo that will stay with you forever." — Dan Smith

Dan Smith

HIS BEST FRIEND

Dan Smith and I worked together at a tattoo shop in Arcadia for about a year. I left in 2003 to work in Hollywood, and he was always on tour with his band, the Dear and Departed, so we didn't see each other very often. But when we did, we picked up just where we had left off. We'd talk about the shops we were working at, the art we were doing, and what tattoos we'd gotten since the last time we saw each other.

I never imagined that Dan would want me to tattoo him; most of his collection consists of full-color, traditional-style tattoos. When he asked if I would take on a large portion of his ribs, I was simultaneously surprised and flattered.

For me, it's always more intimidating to tattoo a fellow artist since a trained eye can pick up on any imperfection.

Kenny Fong

HIS PARENTS

> "To be able to see my parents every day on my forearms is priceless. It feels like they are always here with me." — Kenny Fong

The first time I tattooed Kenny, I did a black-and-gray portrait of his mother on one forearm; the second time, I did a black-and-gray portrait of his father on the other. I had no clue Kenny had such good-looking parents! His mom was actually Miss Arizona back in the day, and you can see why.

As the years went by, we would periodically add more and more to his arms. Even though we began with black and gray, the majority of the tattoos on Kenny's arms gravitate towards full color. I don't think that even Kenny had a sense of how much arm space he was going to end up dedicating to his parents.

These tattoos were meaningful to Kenny because he loves his mother and father so much. Now that they have passed away, having them on his body makes him feel closer to them.

KENNY'S PARENTS

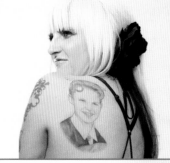

Rhian Gittins

HER MOM

When my best friend Rhian's mom passed away, I was in Florida filming *Miami Ink*. Her loss became a turning point for me. Rhian told me to call my mother and tell her I loved her; when she did that, it confirmed what I was feeling: It was really important to leave Miami and go back home to L.A. In the weeks before her mom died, Rhian would often crawl into her bed, and they would talk through the night — about everything. "I had time enough to tell my mom how much I loved her, how anything good in me, she gave to me," Rhian said. "I also told her that I was going to get a tattoo of her. She laughed and said 'Oh, Rhian!' as she always did, without judgment and with lots of love."

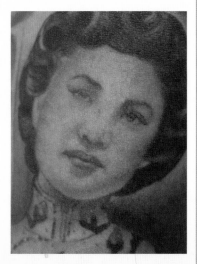

Miss Arizona.

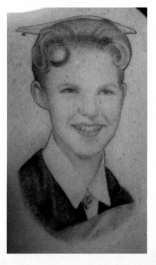

Close-up of the portrait of Rhian's mother.

Disclaimer: Every artist is different. Here are my suggestions for finding a tattoo artist whose right for you. None of these ideas is intended to put anyone down in any way. We all do our thing—here's my way of doing it.

How to Find the Right Tattoo Artist

THERE ARE SO MANY AMAZING AND TALENTED TATTOOERS OUT THERE, yet finding a perfect match can be harder than you think. You want to find an artist who's obviously skilled at the profession, but skilled specifically in the style of work that suits the tattoo you want to get. For example, a tattooer who specializes in a full-color, new-school graffiti style might not be the best person to go to for the black-and-gray unicorn portrait you've been dying to get, and visa versa. Nowadays, with the help of the Internet, researching the array of talent out there is a lot easier. Most professional tattooers have their portfolios online, so you can easily get a sense of what they do.

A well-executed tattoo will always be far more impressive in the flesh. That's why the hands-down best way to see what an artist is capable of is to do so a person. So if you see a tattoo that blows your mind on somebody's arm, ask 'em where they got it and who did it.

Once you find an artist who you totally dig, reach out to them, whether it's via e-mail or by physically going to their tattoo shop. I'm a firm believer that the relationship between the artist and client is all important. You need to make sure you get along, and you definitely want to be on the same level. This isn't because you or the artist need any new friends, but because you want to make sure he fully understands your vision for your tattoo. More important, you want to make sure this person actually wants to take on the job, because ultimately, if the artist isn't into the idea, it's probably not going to happen, and if it does, it won't be the best it can be.

Don't be afraid to travel for a tattoo. People do it all the time, including me! I've made appointments with artists from Ohio to Spain and everywhere in between. And no, it is not crazy to fly in for your appointment—this is something you're going to be wearing for the rest of your life!

How to Choose the Right Art for a Tattoo

YOU CAN NEVER HAVE TOO MUCH REFERENCE WHEN IT COMES TO GETTING A TATTOO. So bring all the visuals you feel might help guide your artist in the right direction. Let's say you want to get a pinup girl. You can bring in several images (they don't have to be anything fancy) and say, "I like the way this one is posing, but I prefer that hairstyle. And this one has the outfit I have my heart set on."

Your artist can help focus your idea and still take creative freedom with other facets of the pinup tattoo, like backgrounds and other artistic flourishes and personal touches, creating something both parties will be stoked about.

For a portrait, you'll want to get more specific. Choosing the right photo is nearly as important as finding the right artist.

Bring a crisp and clear image of the person you want to get tattooed—this is integral to the success of your portrait! A close-up of the face is always better than a photo taken by someone standing twenty feet away; no matter how good your scanner or printer is, most images get pixelated when you enlarge them too much. This also applies to wallet-size photos.

A good portrait tattooer is going to be able to capture every little detail that makes the picture unique, so a blurry Polaroid from the 80s is probably going to cut out important details, such as eyelashes, which can make or break a good portrait tattoo.

Don't bring in a drawing your buddy did, either. The last thing you want is a rendition of someone else's rendition of your mom's face. Accuracy can get lost in the translation, regardless of how skilled your friend is. So bring the original photograph.

For Those About to Rock [We Salute You]: Musically Inspired Portraits

I've tattooed everything from band logos to song lyrics to portraits of musical heroes on people, because much like tattoos, music is one of those things that gets you through the rough times. Music is second only to tattooing when it comes to my personal list of obsessions. Music has not only inspired my tattoo shop, but also plays an important part in my style, my art, and the way I tattoo. My collection of music is made up of an array of genres, from all the classical composers to mid-1950s R&B and doo-wop to Norwegian black metal—and everything in between.

At the shop, we get many requests for tattoos influenced by favorite bands, musicians, and songwriters, and I'll bet that number will rise, because the more tattoos gain acceptance in society, the more people will translate their passion for music onto their tattoos.

Musically influenced tattoos are probably the ones I get most excited about, especially if I'm a fan of the musician, songwriter, or band. Some of the most memorable ones I've done so far include Dolly Parton, Billie Holiday, Slash, Ville Valo, Hank Von Hell of Turbonegro, Beethoven, and Malcolm and Angus Young of AC/DC, whom I tattooed on Scott Ian, guitarist of Anthrax.

> "Eventually, I want to get Phil Lynott from Thin Lizzy, and maybe an Iron Maiden one, too." — Scott Ian

When Scott Ian put in his request to get Malcolm and Angus Young tattooed on his arms, we planned on doing both tattoos in the same day. But since I had to tattoo him during the filming of *LA Ink*, the process took longer, so we started with Angus and did Malcolm a week later.

As we conversed about music during the tattoo sessions, Scott explained to me that AC/DC has a huge influence on his development as a guitarist. His tattoo was a rad way to pay tribute to those who inspired him.

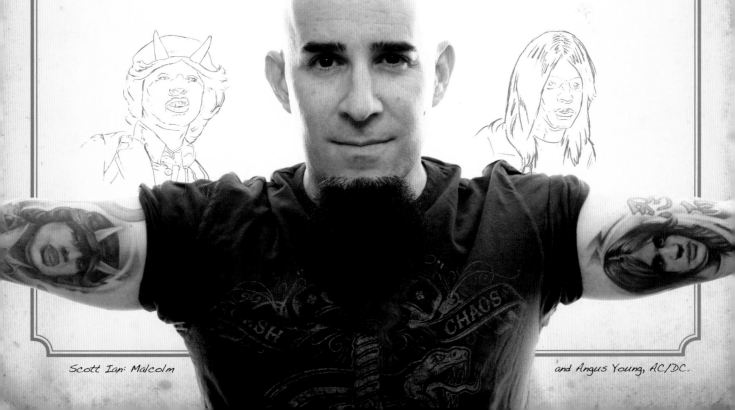

Scott Ian: Malcolm *and Angus Young, AC/DC.*

Alana Beck: David Bowie

{ "I went to my first David Bowie concert when I was two years old. My mom painted a little lightning bolt on my cheek."
—Alana Beck }

The first concert Alana Beck ever went to was a David Bowie show. Her mother was a 70s porn star and groupie who was into the music scene, and when Alana was just a little kid, her mom took her to a Bowie concert. The experience really affected her. "I remember that concert so vividly," she says.

In fact, Angie Bowie, his first wife, actually baby-sat Alana until she was eight years old; her mom knew Angie from the music circuit. Alana says, "She took care of me when my mom was off doing her thing."

Alana's love for David Bowie, it turns out, is a family affair. Her mom loves David Bowie as much as Alana does—maybe even more, since her lifelong goal was to sleep with Bowie. When she finally got the opportunity she passed it up, explaining to her daughter that he was such a god to her that she didn't want to ruin it by getting to know him in such a human way. I have a picture of Alana's mom on my wall in all of her 70s porn-star glory, arms raised, mouth open, legs spread. Alana plans on having her mom tattooed on her leg one day. But for today, it was all about David Bowie.

As Alana grew up, she kept going to Bowie shows. She had some friends who worked at the Wiltern in Los Angeles, so when Bowie played a show there, she got to meet him backstage. "It was incredible!" She beamed when she asked me for this tattoo.

Her request made perfect sense to me, since Bowie had been a presence in her life since she was just a child. We had initially discussed doing an entire sleeve with a glam rock theme, with images of Bowie, T. Rex, and other classic performers of the genre, but we had a hard time finding the right photos. Bowie is such an iconoclastic image—and Alana loves him so

much—that she decided Bowie alone would provide enough content for an entire sleeve. She wanted to include close-up face shots, candid shots, and maybe even his mug shot from 1976, when he was arrested in Rochester, New York, for marijuana possession.

We began the project with a photograph of Bowie that was shot during the Ziggy Stardust–era and placed the image on her upper arm. The photo was really interesting to work from, with great details: the wild makeup, the glitter on his face, the texture of his hair—and the fact that one of the pupils in his eyes was abnormally larger than the other. As an artist, it's these details that create challenges, making the tattoo fun for me to do.

Our next project after Bowie? A good old-fashioned portrait of Mom.

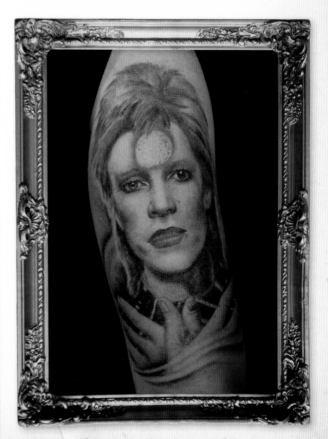

Ground control to Major Tom...

Vains of Jenna

Vains of Jenna is one of the raddest bands to come out of Sweden since Abba. There used to be a skateboard ramp in the front of the shop. We threw a big skate ramp bash, and Vains of Jenna played at the party. These guys really believe in their music, and they came to the U.S. and just made it happen.

This tattoo was a gift to the bass player for playing at our party.

FROM LEFT TO RIGHT: *Michael Starr's color nautical star. Lexxi Foxxx's Japanese-style, full-color chest piece. Portrait of Michael's mom, back when she was a porn star. Day of the Dead-themed leg sleeve.*

Steel Panther

If I was going to be a groupie, I'd be a groupie for Steel Panther, a rock group that covers 80s bands like Def Leppard and Guns N' Roses and Mötley Crüe. They do an excellent parody and always have a great time making fun of themselves and the audience. They're really talented—they sometimes sound better than the original bands! Everybody in L.A. loves Steel Panther. Tattooing them was just as fun as going to hear them play.

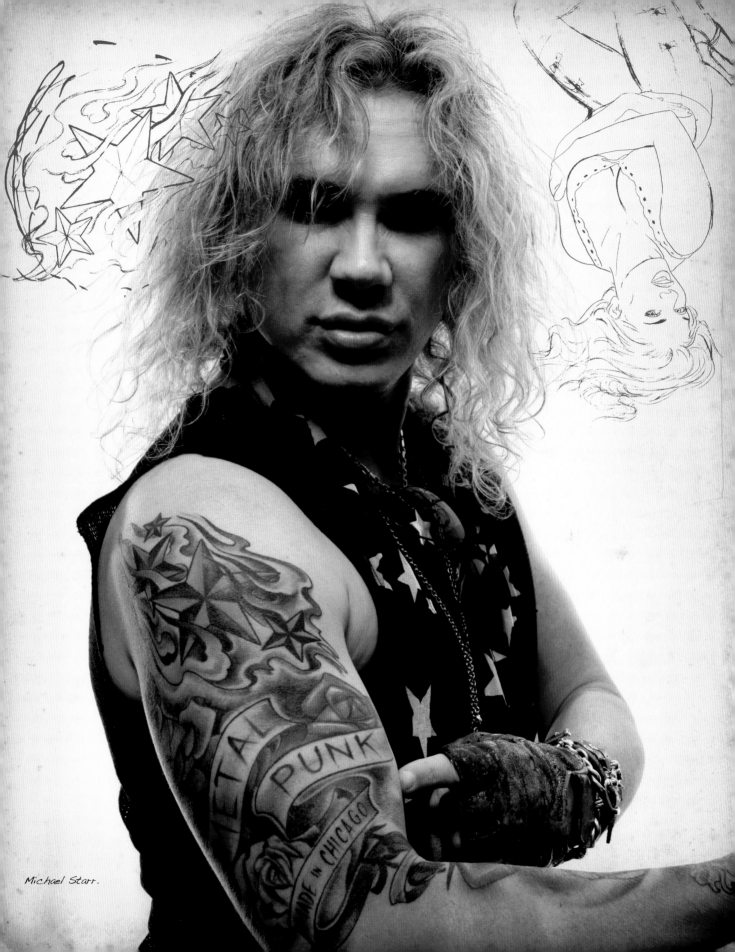

Michael Starr.

Rhian Gittins

BRIGITTE BARDOT

{ "To have Kat, my soul sister, tattoo such an 'I don't give a fuck'
blonde bombshell on my arm as a gift to carry with me always
is feline and powerful, much like Brigitte herself!"
— Rhian Gittins }

One of my favorite things to do is to give a new birthday tattoo to a close friend. It makes a sweet gift, and personally, I always love to get a new piece around the date of my birth, so making that happen for my friends is almost like a gift to myself!

One year, for my best friend Rhian's birthday, I set out to give her a tattoo she would absolutely adore forever. I didn't know what that would be exactly, but I knew she had a nice piece of real estate on her right forearm that was up for grabs.

Rhian came prepared to claim her birthday tattoo fully loaded with some of the most amazing photos of Brigitte Bardot (not that there are too many bad ones out there). Together, we agreed on the perfect photograph for the space on her arm that we wanted to cover.

Rhian's been into Brigitte Bardot since she was in seventh grade. She was in the basement at a friend's house when she discovered a stack of old *Playboys*. The April 1969 issue featured a spread of Brigitte Bardot that made her catch her breath. Rhian loves boys, but she thinks that everyone is beautiful— especially Brigitte.

This has become one of my favorite portraits, not only because of the image, the tattoo, and the placement, but because of the person who wears it.

Shane Rucker

JAMES BOND

I don't think I've ever had this much fun doing a color tattoo. When Shane Rucker brought in a huge poster from the classic James Bond flick *Thunderball*, I was beyond thrilled! I knew color would take longer because it always does, but the idea of laying each of the three distinct scenes from the movie poster vertically down Shane's leg was a challenge I could definitely get into. I made a line drawing based on the poster art that she brought in.

In terms of the tattoo, the work I did on Shane's thigh piece can be broken down into four stages: line work, black-and-gray shading, color, and highlights. We did the tattoo in three four-hour sessions. In the first session, we did the line work and some of black-and-gray shading. The second session was dedicated to shading and color. In the third, we finished the color and added the highlights. The finished piece has three panels, each section depicting a different scene in the film.

When I complete a tattoo, there is always an element or detail that I love the most. Subtle little details can make such a huge difference in the final outcome of a piece. Sometimes it's the way an ear or an eyebrow turned out, but in Shane's case, my favorite detail is the way the bubbles look in the underwater scene.

Matt Skiba: SPINAL TAP AND CONRAD VEIDT

> "I love *The Man Who Laughs* and I'm a huge Batman geek. I love the image and the history behind it. Obviously, Kat is absolutely amazing with portraits, so her wanting to do this for me was a huge inspiration!"
>
> —Matt Skiba

I first tattooed Matt during the filming of *LA Ink* a while back, but we had only met a few brief times prior to that. Right off the bat we clicked, and quickly became good friends. I was so stoked on Matt's idea for a tattoo. First, he wanted some lettering on his ribs reading "Hello Cleveland!" This phrase is an inside joke for any of those who had seen *Spinal Tap*, a mockumentary on the rock 'n' roll world of a struggling band. I'm such a movie geek that I knew right away what Matt was talking about when he presented the idea for his tattoo to me.

I knew Matt sang and played guitar in Alkaline Trio, not just because of their huge following, but because of every Alkaline Trio logo I've had to tattoo in the past! When my friend Jeffree Star, who has great taste in music, played me the album of Matt's side project *Heavens*, I freaked out on how much I related to their whole vibe. Whenever I hear Matt's music I get an overall feeling of love, death, and hopeless romance.

Since that first tattoo, I've had the honor of tattooing a portrait of the German silent film star Conrad Veidt on Matt's right calf. Conrad Veidt starred as Gwynplaine in the movie *The Man Who Laughs*. Veidt's character, with his creepy smile, later became the inspiration for the original Joker character in the early Batman comics.

The man who laughs.

The man who refuses to smile.

DARREN ZIMMET: MONSTERS, INC.

Darren has done great job of collecting great images from film. Here are his tattoos and the line drawings I did for them.

FROM LEFT TO RIGHT:
- Béla Lugosi.
- Béla Lugosi line drawing.
- Frankenstein.
- Line drawing for Frankenstein.
- Beetlejuice, Beetlejuice, Beetlejuice!
- Beetlejuice line drawing.

Andrew Tonkery: JOHN CANDY

{
"If I'm ever having a bad day,
I just look down at my arm and can't be mad
anymore; I have JC on my side!"
—Andrew Tonkery
}

We knew this tattoo was headed in the right direction when the line drawing looked just like John Candy.

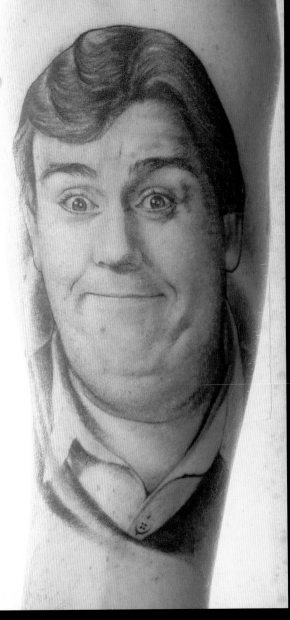

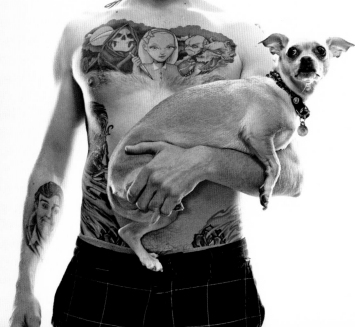

MOVIE-INSPIRED LINE DRAWINGS

FROM LEFT TO RIGHT:

- *A line drawing of Joan Crawford holding a hatchet. I did this tattoo on Cedric Bixler-Zavala of the Mars Volta to add to his collection of black-and-gray tattoos.*
- *Rita Hayworth.*
- *Janet Leigh in Hitchcock's Psycho.*
- *Marilyn Monroe.*

Tattoo Etiquette

DON'T COME WASTED TO YOUR SESSION. Making lifelong executive decisions shouldn't be made while under the influence of anything. I would hate to give someone a tattoo they might regret the morning after. But aside from that, there's nothing more annoying than tattooing someone who's completely hammered. When you're drunk, it's hard for you to sit still, making my job harder, and adversely affecting the quality of the tattoo. Plus, drunk people are known to get loud and crazy, and just because you want to party doesn't mean you should do it in my tattoo shop (or anyone else's).

BE ON TIME. Most tattooers worth getting work from are going to be booked. With that in mind, if you show up to your appointment late, this affects your artist's schedule for the rest of the day. I know that shit happens and that you can't control the traffic, but punctuality is always appreciated. Worst case scenario, if you are running late, it's always a good thing to call and let your artist know.

DON'T BARGAIN. "Good tattoos aren't cheap, and cheap tattoos aren't good." —Sailor Jerry

When it comes to your tattoo, the old saying "You get what you pay for" says it all. Price should not be a deciding factor. Would you bargain with your doctor or your plastic surgeon? Sure, you can go the cheaper route and risk getting a lopsided boob job—but if you ask me, that risk ain't worth the gamble! It's not like buying a stylish pair of shoes or a leather bag. Tattooing is a permanent body modification, and a tattoo shop is not a swap meet. It is offensive to an artist when people try and bargain the price of a given quote. Trying to talk down the price only translates to, "I don't think you are good enough to pay that much," to your artist.

DON'T BRING CHILDREN WITH YOU. Although tattooers are skilled multitaskers, you shouldn't count on them being able to do your tattoo and babysit your kids at the same time. And you shouldn't assume that you'll be able to get a tattoo while you're keeping a watchful eye on your children.

Depending on county regulations, most shops don't allow minors into a shop, and for good reason. When you think about it, some kids are the same height as our trash cans. And those trash cans are filled with materials considered to be biohazardous. I know that if it were my kids, the last place I'd want them playing hide-and-seek would be an environment with that kind of stuff around.

If tattoo shops were rated like the movies, I'd say most would be somewhere between R and NC-17! There is cussing involved, and discussion of adult-oriented subject matter that may not be appropriate for young ones. This is a one-size-fits-all rule and includes babies, toddlers, tweens, and teens. (Yes, even your especially polite and quiet kid.)

DON'T ASK TO PLAY YOUR MUSIC. Being an obsessive music fan, I know how it feels to really be into your personal collection of music and portable playlists. You want to be comfortable when you're getting a tattoo, but you mostly want your artist to feel comfortable. Just as much as I love certain music with a passion, the same passion goes for music I dislike, and there's no nice way of saying, "Sorry, buddy, I don't trust your musical vibe." Putting an artist in that awkward position is the last thing you want when somebody is about to tattoo you.

EAT SOMETHING BEFORE YOUR APPOINTMENT. Before you get tattooed, make sure you've had a meal or a snack. Clients who arrive hungry may get dizzy or even faint. It's more common than you think, so even if it's a candy bar, eat something.

DRESS THE PART. Make sure to wear clothing that allows easy access to the area on your body you plan on getting tattooed. Focusing on your tattoo in order for it to be perfect is hard enough without a strap or some complicated shirt getting in the way.

TAKE A SHOWER. This one is self-explanatory—or at least I hope so. Don't count on anyone around you being stoked about the way your armpits smell after working out for three hours. I remember having to tattoo this one guy on the inside of his bicep near the armpit, and boy, oh boy—it seemed like there was nothing on this planet that would make time go faster.

DON'T BE A TATTOO ADVISER—and don't bring one with you, either. I can honestly say that I hate when a client brings along a buddy who is more sure about the tattoo than the guy who is getting it. If you're not 100 percent sure about what you should get, you should wait until you are.

If anybody ever asks you to be their tattoo adviser, remember this advice. It doesn't matter if you like the placement or the design. It isn't your body.

DON'T BRING AN ENTOURAGE. Bringing one friend for moral support (not to be a tattoo adviser) is totally cool. But I promise you, even though it may sound like a good idea to invite all of your first, second, and third cousins, it isn't. There may not be enough seating, so some of your homies will be forced to stand for hours and will most likely find themselves getting in the way a lot. Besides, it's not that fun for them to stare at a wall for the hours the tattoo may take. And it can be distracting for your tattooer to have to play host. So leave your friends at home and surprise them later with your brand-new piece of portable art.

DON'T TALK ON YOUR CELL PHONE. No one wants to hear you tell your mother what you ate today, the fight you're having with your cheating girlfriend, or the debate between you and your lawyer about whatever business deal you're trying to close. Don't be the "inconsiderate cell phone guy." Please!

DON'T GET A TATTOO IF YOU'RE PREGNANT. Being tattooed raises stress levels and affects your immune system. If you're pregnant, these are two things your doctor will tell you to avoid during those nine months. Any good tattooer will refuse to tattoo a pregnant woman.

Jeffree Star

PRINCESS DIANA

SHARON TATE

Jeffree Star is a young, fierce, gorgeous pink-haired creature, all legs and pout with flawless makeup and a year's worth of attitude. He's obsessed with the obsession the world has for these lovely creatures—even after their deaths. And his body is a testament to that.

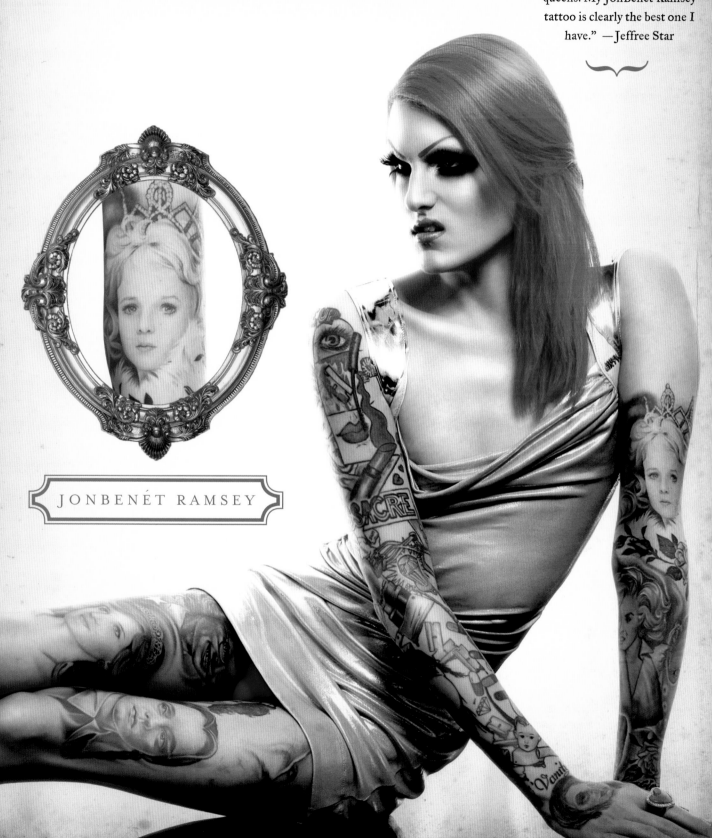

IN LOVE WITH BEAUTY

"I've always had such a huge fascination with dead beauty queens. My JonBenét Ramsey tattoo is clearly the best one I have." —Jeffree Star

JONBENÉT RAMSEY

Darren Zimmet: GWEN STEFANI

{ "I've been in love with No Doubt since the fourth grade. Gwen's actually seen my tattoos in person on a few different occasions. She loved them! She actually brought her parents over and showed them the tattoos at a recent event."
—Darren Zimmet }

The first time I met Darren Zimmet, he asked about getting a portrait of Gwen Stefani. He wasn't old enough to get tattooed, but he explained that he wanted to plan ahead. This was my first request to do a Gwen tattoo, so our conversation made an impression on me. I had done tons of Marilyn Monroes, an Elizabeth Taylor, a Rita Hayworth, even a few Sandra Bullocks, but never a Gwen Stefani.

The next time I saw Darren, three years later, he was eighteen, of legal age to get the tattoo that he had so patiently waited for. The image he brought was a great photo, too. Gwen looked totally sexy in a tie that hung all the way down to her gold belt buckle, which clearly spelled out the words "No Doubt." Her hair was styled in a blonde pompadour and she was rocking ruby red lips and a sultry look in her eye. There were lots of cool details, which made the tattoo interesting for me to do.

It's crazy to think that some people react in a negative way to Darren's Gwen tattoos. With all the shows that Darren has attended, he has been able to meet Gwen, show her the tattoos, and hear what she thought about them. Her feelings were positive, because she understands that he is inspired by her and No Doubt. That in itself is pure.

Four Gwen tattoos and a load of other tattoos later, I believe Darren has one of the coolest collections of tattoos I've done on a person, including one of his favorite album covers, No Doubt's *The Beacon Street Collection*.

Left: Darren Zimmet's second Gwen tattoo. When you look at it closely, you can see the reflection of the photographer in her pupils.

Center: Based on the album cover for No Doubt's The Beacon Street Collection.

Right: Darren's third Gwen tattoo, complete with Gwen's signature G key.

Neil Sheehan: JAMES DEAN

Neil Sheehan, the founder of HM Live, a concert and management company, is James Dean's biggest fan and considers Dean one of his heroes. He even self-published a book on him: *Thoughts, Quotes, and Feelings about the Late Great James Dean.*

While you've heard me say again and again how much I love to do portraits, of course, it's not the only thing I do. There are so many inspiring sources for tattoos, and I like to use as many as possible.

A TATTOOER CAN'T LIVE ON PORTRAITS ALONE!

PART IV

IF YOU WANT BLOOD, YOU'VE GOT IT

THE
GALLERY

attooing is incredibly versatile. You can find inspiration from any medium any corner of our culture: in a museum in Madrid, in the small theater downtown that occasionally plays your favorite classics—or in your band's art. Some people take their tattoos really seriously, while others don't give a rat's ass and will gladly tattoo themselves with something just because it strikes their funnybone. That's what's so amazing about tattoos—whether they are inspired by Picasso or a friend's stupid one-liner, they're all about your personal tastes.

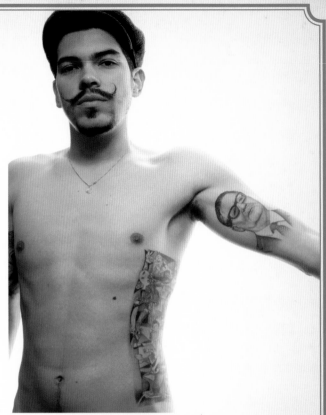

Steven Hernandez: *GUERNICA*

> "The outline took forever because there were so many lines. And Kat said, 'There's more lines in this tattoo than a coke party.'"
> —Steve Hernandez

I met Steve Hernandez when I was working at True Tattoo. I gave him his second tattoo, an angel, which came out from behind his first tattoo, a crucifix. When he was inspired to go bigger, he came back to me with a dazzling idea—he wanted to have Picasso's *Guernica* tattooed on his rib cage. Steve was a political science major who had taken a lot of art classes in college, and he was very taken with the idea of Picasso being so outraged at the desecration of the town of Guernica. His two interests collided in Picasso's masterpiece, and I agreed to tackle the challenge.

Completing the piece took nearly two years. Of course, this wasn't all in one sitting. Ha! I did the outline in one sitting, but then I had to go to Miami to start filming, and the next time I saw Steve in L.A., I completed the top half of the painting. When *Miami Ink* ended, we met up and I finished the job. Man, did my eyes hurt on that one. There were so many fine lines that I could barely see after a while.

Altogether, this tattoo took about eight hours.

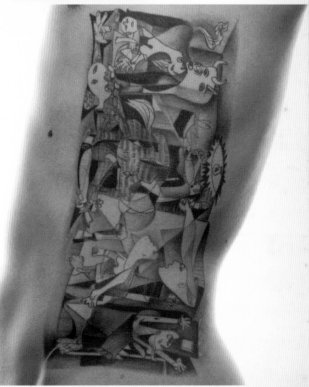

Top: Guernica by Picasso by Kat. Salvador Allende is on Steve's arm.
Bottom: Detail of Guernica.

> "It seems like some people just say, 'Oh, let's just get tattooed!' And a lot of musicians are getting stuff that doesn't make any sense. For me, it's always been about the places that I've been and things I've seen in the short time I've been alive. . . . It's like a scrapbook of my life."
> —Frank Iero

Frank and Frank.

I was working on *Miami Ink* the first time I met Frank Iero. My Chemical Romance was in town, around the time that their album *The Black Parade* went platinum.

Frank wanted a Frankenstein tattoo on his forearm, but all of the images he had collected were portraits I had already done on other avid horror-themed tattoo collectors. I'm a firm believer that when it comes to getting a tattoo, you should really try your best to separate yourself from others. Be unique! As an artist, I tend to steer away from doing the same tattoo more than once.

Luckily, my dear friend Jovanka Vuckovic, editor in chief of the magazine *Rue Morgue*, was only a text message away. Before you could say "Frankenstein," I had about twenty rare photos in hand, some of which neither Frank nor I had ever seen. This was a real thrill for both of us!

Once Frank came to a final decision about the image he wanted, I began preparing to do the tattoo. Gathering all the crucial supplies in order to tattoo someone on a tour bus can be tricky. I mean, first of all, I had never met Frank before so I had no clue how big he was: all I had was an approximate measurement of the size he was thinking the tattoo should be on his forearm. Since making the stencil for a portrait ahead of time is probably one of the more important parts of preparing to do a tattoo, I had to make stencils of the line drawing I did in about five different sizes, just to make sure I was covered.

I put together all my basic setup gear, including tattoo machines, power supply, clip cord, foot switch, rinse cups, green soap, isopropyl alcohol, wipes, dental bibs, medical tape, gloves, ink caps, ointment, bandaging material, disposable needles, disposable tubes—disposable everything!—and a stack of my favorite precut paper towels. I gathered up all the necessities, along with my stack of stencils, and I headed off to the outdoor festival where the band was playing.

I headed backstage, where the band's tour manager led me to Frank's bus. Frank greeted me with a hand shake and a kind smile, and it was immediately apparent to me that he was a down-to-earth, good guy. I always find it so refreshing when a musician who has made it remains a grounded and humble person. Right off the bat, I knew Frank and I were going to get along.

Frank had a few hours before he was due on-stage, so there was no rush, which is always nice. Our main topic of conversation was, not surprisingly, Frankenstein. I quickly learned how passionate Frank was about horror films—he was a self-confessed horror-movie nerd.

We were both elated to have found such a great rare image on short notice. The photograph I worked from showed Frankenstein standing with his larger-than-life creeper-style shoes, high-water slacks and matching blazer, his arm extended up, gripping a chain that leads to God knows where. I figured that since Frank already had a bunch of tattoos and would probably get more, it would be wise to have the chain dissolve into nothing, as opposed to having a harsh line to end it.

When we had finished, I headed home, and Frank and Frankenstein were ready to rock out onstage.

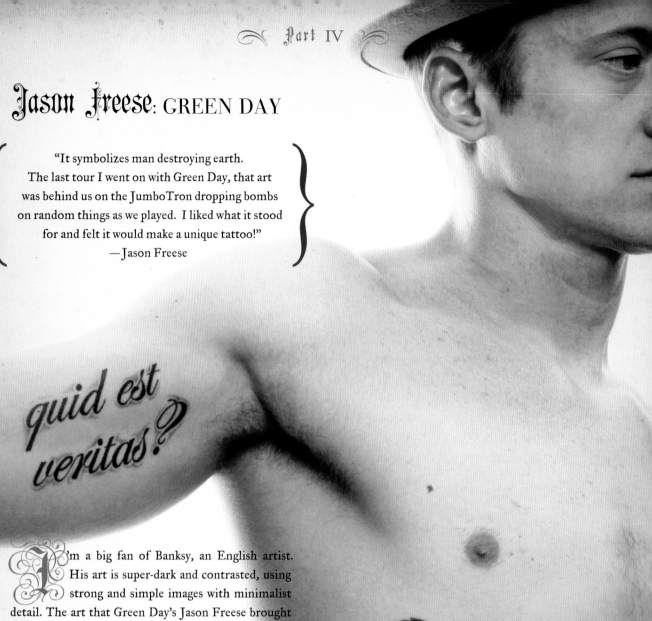

Jason Freese: GREEN DAY

> "It symbolizes man destroying earth.
> The last tour I went on with Green Day, that art
> was behind us on the JumboTron dropping bombs
> on random things as we played. I liked what it stood
> for and felt it would make a unique tattoo!"
> —Jason Freese

I'm a big fan of Banksy, an English artist. His art is super-dark and contrasted, using strong and simple images with minimalist detail. The art that Green Day's Jason Freese brought me for this tattoo was reminiscent of Banksy's style. It was simple: a black graphic image of a man with his arms extended, flying and dropping bombs from an open bomb hatch. I knew I would use the same technique I use when doing a tribal design and make it completely solid.

After looking at the simplicity of the design, the idea of sneaking in a little bit of texture—especially in the man's face and on the curvature of the bombs—was appealing to both of us, but it was critical for me to not go too light or too dark on the shading. If the tattoo was too light, it would look weak, but if I went too dark, you notice the subtleties that made it special.

In the end, we were both thrilled with the result!

After more than a decade of hearing the rumors associated with tattooing, I thought clearing the air of these myths would help answer some of the questions tattooers are (too) often asked!

TATTOOS CAN BE DONE IN "GLOW IN THE DARK" INK. As much as it sounds like a good idea, there is no such thing, and if there was, I for one wouldn't feel comfortable inserting all those chemicals under my skin. Some people tag their pets with a tattoo at the veterinarians in order to identify them in case they get lost. Some of these markings are performed with "black light" ink. These pigments aren't as visible as standard tattoo pigments, but will glow under a black light.

YOUR SKIN GOES "NUMB" DURING A TATTOO SESSION. No, it doesn't. But man, sometimes I sure wish it did! Realistically, the longer your tattoo session goes, the more irritated your skin will feel. But your body naturally produces endorphins under high level of stress. These are the same endorphins you might feel after a rigorous workout or an intense rollercoaster ride. They act as your body's self-defense mechanism when you have sensory overload (like when you're being tattooed), and this can give the false feeling of being "numb." Endorphins fade after time: most clients give out after a good three hours of tattooing.

TATTOOS ARE ADDICTIVE. Physically, there are no chemical dependencies involved in getting a tattoo. I think some people view tattooing as an "addiction," since it's rare to see a person with only one tattoo. Usually, if people are put off by how much they think a tattoo will hurt, but have their heart set on getting one, they go through with it and in turn realize that it wasn't so bad. From that point on, getting another tattoo doesn't seem like that much of a big deal. The next thing you know, you're planning your next tattoo, and then the next one. But this in no way is a physical dependency.

DRINKING ALCOHOL BEFORE GETTING A TATTOO WILL FADE YOUR TATTOO. This false concept stems from the idea that if you bleed a lot, your color is somehow filtered out through the blood. Although alcohol is in fact a blood thinner, the effect it has on how much you bleed during your tattoo is minimal. I've tattooed clients who were on hardcore blood thinners due to diabetes, and the only difference I could see in the process was a noticeable amount of irritation. This occurs naturally in some skin types anyway.

But I can see why tattooers would confirm a rumor like this. I mean, no one wants to deal with a drunk-ass client. At least I know I don't!

SOME COLORS HURT MORE THAN OTHERS. There are no ingredients in certain tattoo pigments that cause extra pain during a tattoo.

GETTING TATTOOED ON FATTIER AREAS OF THE BODY HURTS LESS. Pain levels during a tattoo do not depend on how much fatty tissue you have. Believe it or not, your ass is one of the most painful places to get tattooed, and anyone with a body suit can confirm this. If someone is skinnier or heavier, it still won't matter. What it comes down to is your nervous system, not the size of your ass.

GETTING YOUR LOVER'S NAME TATTOOED PUTS A CURSE ON YOUR RELATIONSHIP. I have more than ten of my exes' names tattooed, and I'm almost positive the tattoo was never the reason for our breakups. Ha!

The oldest person I ever tattooed was an eighty-two-year-old man. He came into the shop with his wife in hopes of touching up a tattoo he had gotten in the 1920s. Before he could even show me his faded tattoo, I tried to persuade him to leave it as it was. A tattoo like that is like a piece of history. You're supposed to grow old with it, it's supposed to age with you. It's a reminder of times passed, regardless of whether the color has faded and the lines have become blurry.

Determined, the man proceeded to lift his sleeve, only to reveal a tattoo so aged it was difficult to tell what it was right off the bat. I eventually figured out that it was a traditional red heart, with a banner that read "Helen." Helen was the woman standing next to him, he explained, and it was their anniversary. Making this tattoo legible for the entire world to see was a gesture of loyalty and true love for his wife. It seemed so appropriate.

BAM MARGERA
FREEHAND FILIGREE AND LATE NIGHT FUN

> "I'm not bummed out about any of
> my tattoos. It's kind of rad in a way, because they
> all have funny stories behind 'em. Every time
> I look at them, they make me laugh!"
> — Bam Margera

I met Bam Margera at the Rainbow on Sunset Boulevard, but he was so wasted he still thinks we met in Finland. Although we have hung out in Finland, it wasn't until a month or so after our first meeting that we partied hard at a music festival called Ruis Rock. The band HIM was headlining as well as some of our favorite Finnish bands, like Hanoi Rocks, the 69 Eyes, Sentenced, and Children of Bodom.

My room was the headquarters for drunken tattooing, and that night, our crew all got matching tattoos. The tattoo was DILLIGAF, an acronym for *"Does It Look Like I Give A Fuck?"* This tattoo is my motto, because I think it's important to do what you believe in, no matter what anybody else thinks. That night I gave little DILLIGAFs to my friend Jen, to several members of HIM, and to Bam. Things got rowdy, and at some point, Bam told Ville Vilo that he was an idiot.

"Did you call me a nidiot?" asked Ville.

They thought it was so hilarious that they both immediately asked to have the word "nidiot" tattooed on their asses.

The next morning, word got out that Bam and Ville (who sings lead vocals for HIM) got DILLIGAF tattoos, and a fan went to the local tattoo shop in Finland and tried to copy them. The fan didn't know what it stood for, and the tattoo artist accidentally

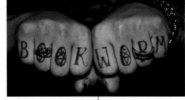

misspelled it as DILLIFAG. When we read about this incident in the paper, we laughed our asses off.

After our escapade in Finland, Bam and I became good friends and would hang during his regular visits to Hollywood. When HIM flew to Los Angeles to record their album *Dark Light* we were hanging out every night. Bam was in the middle of filming *Jackass Number Two*, which included doing a stunt that involved getting trampled by bulls. It didn't sound fun to me, or to him. He tried to negotiate with the director, Jeff Tremaine, to get out of doing the stunt, but Jeff refused.

The next thing you know, I got a phone call from Bam saying, "Give me a grizzly bear humping a kitty and write 'Fuck Jeff!' on it." So I did. Now Bam has that tattoo on the side of his left calf; it's about eight inches tall in black and gray.

I've given Bam some elaborate tattoos as well. One of my favorite pieces is the filigree design that extends from his hip all the way across his stomach to his ribs and up to his nipple. Filigree is one of my favorite styles to tattoo, and if I could do it all over again, I'd choose that style to adorn my entire body.

I have to admit, it's never a dull moment when I get together with Bam. The creative freedom he gives me always makes for some of my best work. Once he came in to get a new piece and told me I could do whatever I wanted to. He said he didn't care, because he trusted that he would like whatever I came up with.

That day, I drew an elaborate piece that I felt suited him: a beautiful girl engulfed in baroque-style filigree with a heartagram tattoo on her upper arm. Bam sat through the tattoo without even looking at what I was doing. When he finally took a peek at what we had been working on, he was as stoked as I was!

FUCK Jeff!

Artwork by: Kat Von D
JUST 4 BAM BAM!

BAM

CLOCKWISE:
· Freehand filigree, which Bam and I both love to have tattooed.
· A guitar made of a skeleton bone; this is one of Bam's skateboard graphics.
· "Fuck Jeff!"
· Designs for Bam's skateboards.
· Lettering samples for Bam's skateboard.

Givin' the Dog a Bone: Animals

Animals have always been an artistic form of symbolism in the tattoo world. In some cultures, a lion represents protection, a cat can mean good luck, a phoenix rebirth. Nowadays, pet portraits have become quite popular, allowing people to mourn and celebrate the life of their companion.

Animal tattoos have a meaning that goes beyond design aesthetics, an appreciation of nature, or an emotional attachment. For instance, a swallow is a prominent image in the history of tattooing. You can find these birds in almost all the flash sheets of tattoo designs from the 1930s to now. Sailors used to get one swallow tattooed on their chest during their departure overseas, and then add a second swallow on the opposite side upon their return home to their loved ones.

There's a reason for this: Swallows are birds of habit. During a certain season, they'll migrate to warmer weather, always returning to their original home afterward. The tattoos represented the sailors' desire to absorb the birds' ability to return home.

Of course, not everybody who gets a swallow tattoo knows why they are so prevalent in flash bibles, but that doesn't mean that there aren't invisible layers that tie us to history, and to the experiences and hopes of people we will never meet. For some, it's just a cool design that looks good regardless of meaning, and for others it represents a promise to return home safely from a long trip far away.

MARGARET CHO

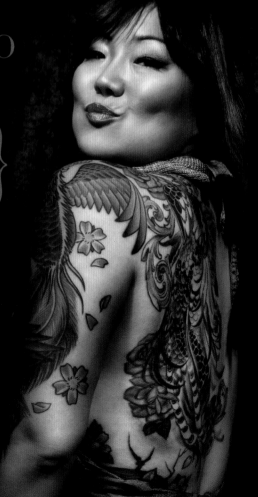

{ "I love heavily tattooed women and men. I think everyone should be heavily tattooed. I don't understand when people don't have any. They're just like blank canvases. What's the point?!"
— Margaret Cho }

Comedian and actress Margaret Cho found the reference image for this magnificent piece in a book on art nouveau. Her reason for choosing the peacock: "I wanted something to remind myself that I am beautiful."

Mythological animals are popular, too. Many are a combination of several animals, each animal part symbolizing a personality trait. A griffin, for example, is a winged monster with the body of a lion and the head of an eagle. A dragon has elements of a koi fish, a serpent's body, and an eagle (the talons). Each of these elements carries meaning that people can relate to, and it's such symbolism that attracts some clients to certain tattoos.

I never thought I'd be compelled to get an animal or even a pet tattooed on me, until I found my pet soul mate, my hairless sphynx cat, Ludwig. Man, that little ball of joy has won my heart over, and before I die, I will have a tattoo dedicated to him!

I've made some crazy connections in this business over the last decade. I met Alana Beck when I was working at True Tattoo in 2006. She came in to ask about getting a portrait of her pet. When she showed me the photo of her cat, a hairless sphynx, I couldn't believe it.

I'd wanted that breed of cat for so long, but I never knew where to get one. When she told me that she was a breeder, I almost started jumping up and down.

After we exchanged contact information, I asked Alana if she would stay in touch and let me know when she would be expecting the next litter. Sure enough, a few months later, Ludwig became part of my life, and I gave Alana this tattoo. I was so much in love with my new best friend, Ludwig, that I wanted to give Alana a gift in exchange for keeping her word. This was the beginning of a new friendship, which led to more tattoos, like the awesome one we did of David Bowie (see page 88).

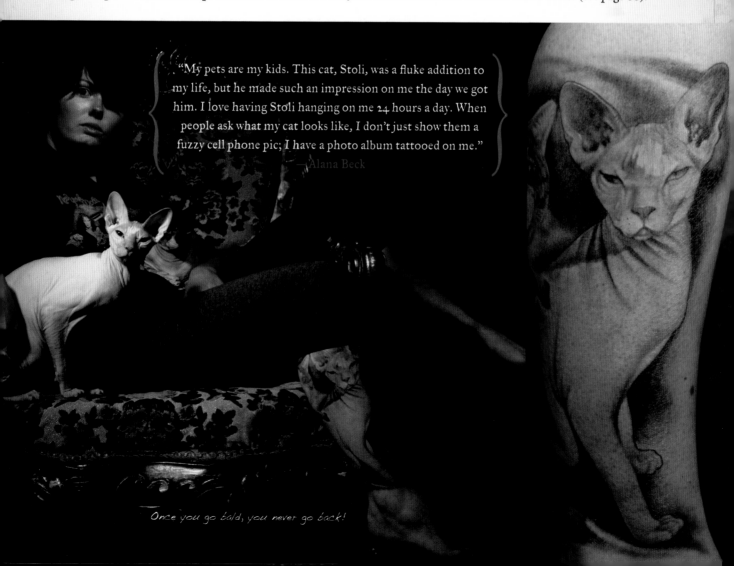

"My pets are my kids. This cat, Stoli, was a fluke addition to my life, but he made such an impression on me the day we got him. I love having Stoli hanging on me 24 hours a day. When people ask what my cat looks like, I don't just show them a fuzzy cell phone pic; I have a photo album tattooed on me."
—Alana Beck

Once you go bald, you never go back!

Dennis Halbritter

ECHO, THE BOSTON TERRIER

"When my wife, Shirley, snapped the shot, I instantly could tell it captured his smiling little spirit. That's the magic that exists between humans and dogs."
—Dennis Halbritter, tattoo artist

Ever since his first day at High Voltage, Dennis Halbritter, has had the same photograph of his Boston terrier, Echo, hanging at his work station. While he's tattooing, he can look up and see Echo looking right back at him. Eventually the photograph inspired Dennis to get a tattoo of Echo, the perfect little American Gentleman (the breed's unofficial name, thanks to its tuxedo markings and even temperament). Working next to Dennis on a daily basis, it would be impossible not to notice how much love he has for his dog, so this was the ideal tattoo for him.

Dennis has a ton of tattoo coverage on his body, but one of the final untouched areas was his upper thigh. Echo fit perfectly there, which was lucky, because I didn't want to go too small on the image. I needed to capture all the important details in the photograph that were necessary to give the tattoo the same angular effect as the image in the photograph. Echo is wearing infant-size slip-on Vans, and each tiny checkered square on those baby kicks needs to be accounted for.

Jamie Thomas

THE KING OF THE JUNGLE

"I've always been inspired by animals, because unlike humans, their agenda is always clear."
—Jamie Thomas

Tattooing Jamie Thomas, an accomplished pro skater, business owner, family man, tattoo collector, and overall rad human being was definitely an event to be recorded in the books. Jamie got one of my favorite animal tattoos—the lion—on his rib cage. Jamie's tattoo is simple, majestic, and tough-looking. Some people associate lions with ferocity, but there is another level to this beautiful creature that is loving and attentive. The lion is the only cat that is permanently social; a lion focuses on the well-being of the family. That's how I think of Jamie.

Proper usage of body space can make a tattoo look striking, even from across a room, and that was the goal when it came to this piece. When you're acquiring something you're going to wear for life, you'd better make sure that it fits.

SLEEVES

BREAKING THE RULES

MIKE VISCUSI

KENNY FONG

ANDREW STUART

MICHAEL STARR

ASHLEY SALLER

Ashley Saller: FAIRY TALES AND LOVE

{ "The funny thing is, the glass slipper in my tattoo ended up resembling my actual wedding shoes! We didn't even plan it that way, which makes it that much cooler." —Ashley Saller }

Love has always been an inspiration for tattoo flash. Some people think that tattooing a lover's name on your body can be a curse instead of a sexy tribute. On the flip side, others think of it as a good-luck charm. More often than not, people end up covering up these tattoos with other ones; still, people keep coming in for them. I myself consider them a guilty pleasure.

Getting a tattoo is not like putting on a ring—you can cover it up with a measure of pain, but you can't just slip it off. It represents commitment and a belief in the possibilities of forever. Ashley's sleeve is a celebration of her marriage that pays homage to love and fairy tales. Her vision for the tattoo was made up of happily ever after–inspired elements, like a glass slipper, a beauty being awakened by her sweet prince, a magic wand, and a castle, all tied together by a sprinkling of fairy dust.

The tattoo took three sittings, each about three hours long. I was able to knock out all the line work and begin some of the black-and-gray shading in the first round. After Ashley healed, we were back at it again, completing all the shading and starting the color, completing sections at a time, until the final sitting. During the last session with Ashley, when her arm had healed, I was able to complete the tattoo, tightening up the most miniscule corners and dialing in all the highlights necessary to give her sleeve the look we were aiming for.

I wanted the sleeve to match Ashley's sensibilities, so I gave it more of an edge than your typical fairy tale. (The Disney stories are all diluted; the original Brothers' Grimm versions are dark, with ominous overtones, not the thing your typical five-year-old would want to hear before bed.) The tree branch framing the castle has minimal leaves and is a bit darker in shading than your typical "happy little fairy-tale tree." And if you look closely at the prince's hand on page 115, you'll notice he is making the heavy-metal hand gesture. These are all details I knew Ashley would appreciate.

And they lived happily ever after... with a twist. Below right: detail of the castle.

Ayesha King: SKULLS AND VENUS FLYTRAPS

{ "I collect bugs. I love the way they look, even though I don't like them in real life." —Ayesha King }

Tattooing Ayesha is always a pleasure! Back in my party-time days, Ayesha and the crew would come down to the shop. We'd do all the preparation for the tattoo, and once that machine started buzzing, the party would begin. Between shots of tequila and Def Leppard tracks, even lap dances weren't unheard of.

Commotion aside, Ayesha's tattoos were always fun for me to do. I'm an admirer of the creepy side of tattoos, so I could definitely appreciate Ayesha's vision for her sleeve. Skulls. Venus flytraps. And flies (because they go with the Venus flytrap she got because it reminds her of the myth of vagina dentata). What a great combination, especially when I was given the amount of space Ayesha set aside for me to work with: her entire left arm. Towards the end of our process, we realized there was room on her upper arm to fit one last thing.

Ayesha has an elaborate collection of human anatomy reference books, and those volumes sparked the idea of adding a skeletal rendering of a rib cage, which fit in perfectly, both spatially and thematically.

Strong enough for Satan, but made for a woman.

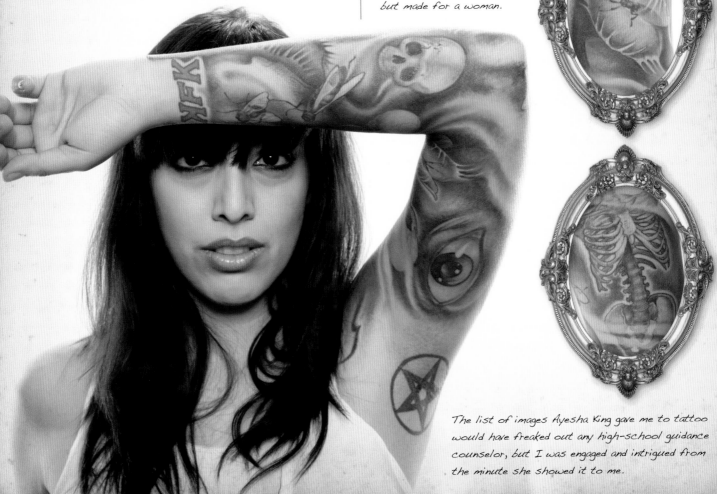

The list of images Ayesha King gave me to tattoo would have freaked out any high-school guidance counselor, but I was engaged and intrigued from the minute she showed it to me.

Kenny Fong: NATURE-INSPIRED SLEEVES

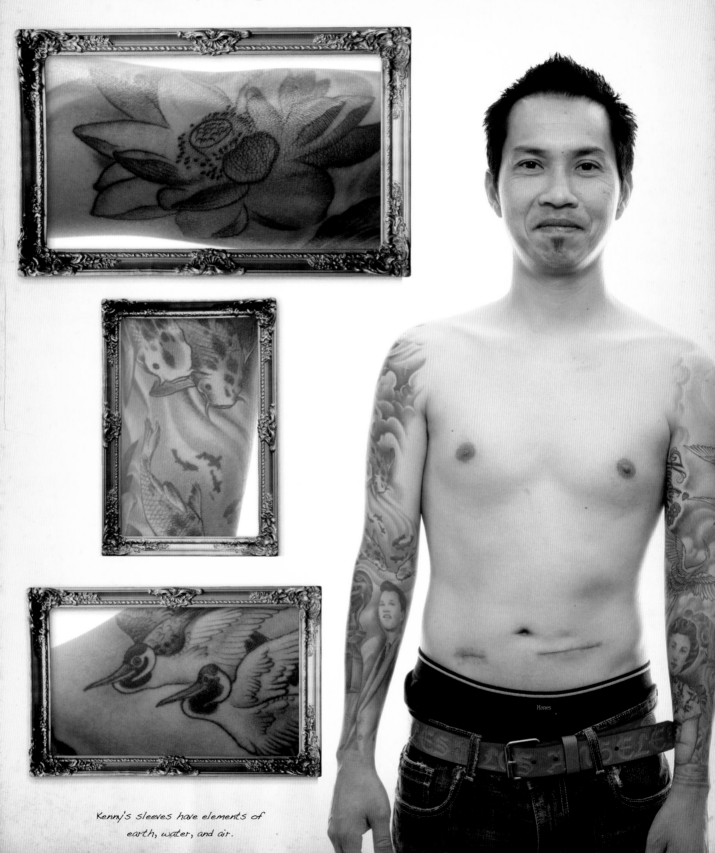

Kenny's sleeves have elements of earth, water, and air.

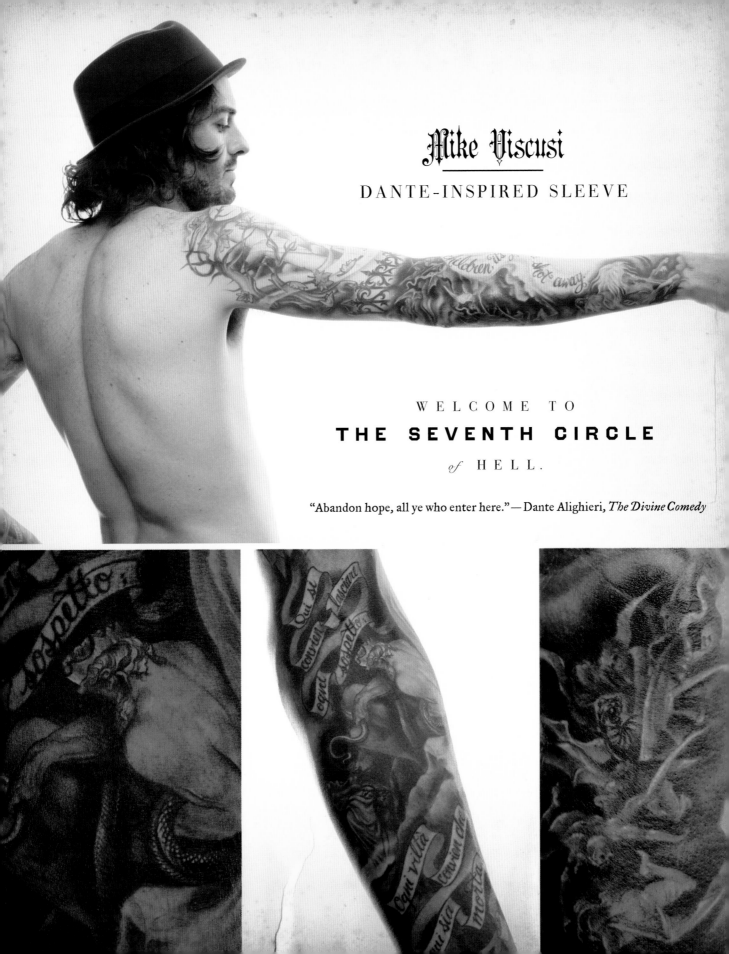

Mike Viscusi

DANTE-INSPIRED SLEEVE

WELCOME TO
THE SEVENTH CIRCLE
of HELL.

"Abandon hope, all ye who enter here." — Dante Alighieri, *The Divine Comedy*

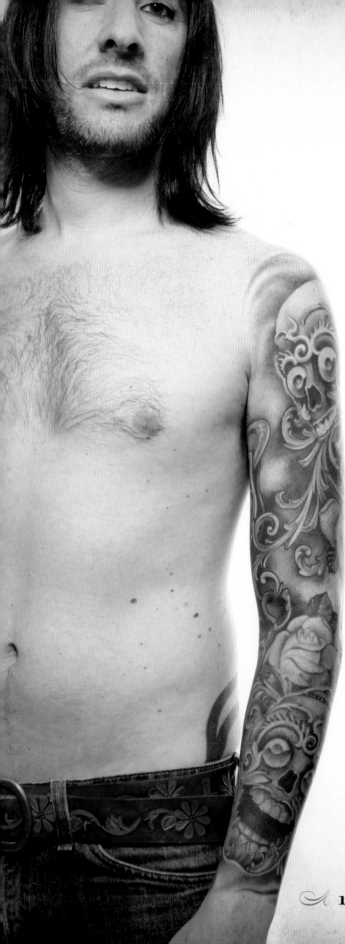

Andrew Stuart

TIBETAN SKULLS, ROSES, KEYS, AND LOCKS

Stu arrived for his consultation well equipped with reference art. When he showed me the manila files full of different styles of skulls, along with a variety of roses, an array of skeleton keys, and an antique lock, I could tell he was a bit on the obsessive side. This is a very good quality to have when you're planning out a sleeve tattoo for your entire left arm.

The majority of the material Stu left wasn't intended for me to replicate as his final design, more to give me the vibe of the style he was aiming at. I think he even brought references of tattoos depicting styles he didn't want to get!

I was thankful for his efforts, and honestly, quite happy that Stu did all the research for me. A lot of people don't realize how much it helps an artist to better understand clients' visions for their tattoo, making the final result more likely to be one that both the artist and client can be proud of.

The steps involved in planning out a large-scale tattoo can be quite time-consuming. The prep work is as important as the actual tattooing, so before Stu left the consultation, I took a tracing of his arm. This is similar to the kind of fitting you would get for a pair of custom leather pants. Once I determined the area that we had to work with, I could more easily transfer the measurements onto paper and map out the bends in his arms, elbow, wrist, armpit, biceps, and other muscles. This helps me decide how to place the tattoo so that the focus is where we want it to be.

Using Stu's reference material, I came up with the final contour line drawing of his sleeve, minus the background, which I drew directly onto his body. He approved the drawing, and we started on this six-session, approximately twenty-hour project. Stu's tattoo was one of the coolest sleeves I've ever done.

The skull hiding in the shadow of the keyhole is Stu's moms favorite part (and she hates tattoos).

One of my favorite things to tattoo is lettering. Strong descriptive words make for a great tattoo. Whether it's a lover's name, the street you grew up on, or your favorite song title, it's a method of self-description. No matter how you style it, no matter what language you choose, lettering is a form of communication.

Script is a particular favorite of mine. It's a wonderful style that many of my clients gravitate towards, guys and girls alike. Women steer towards the swirls and twirls that can be added to the edges of the lettering, while guys may go for the strong, bold, and classic styles.

When choosing a style of lettering, remember that while you want it to look cool, its main purpose is for it to be legible enough for you to get your message across clearly.

BAXTER PAULSON
"I'LL SEE YOU IN MY DREAMS"

When I opened my shop, Baxter Paulson was one of the first people I hired right off the bat. I had known her husband, Charlie, for quite some time; he had been one of my first friends when I moved to Hollywood.

When Charlie hit me up about Baxter looking for a job, I instantly thought to myself, "I wonder if she'd want to work at High Voltage?" Little did I know Baxter would not only win my heart over as a hard worker and supreme shop manager but as a friend. And she hasn't quit yet!

When Baxter's grandfather passed away, I could see how much it affected her. It's hard in situations like these when all you want to do is hug someone, or tell them how much your heart goes out to them, because when someone dies, you mourn for the living.

Charlie came up with the idea to surprise Baxter with a tattoo she had wanted to get in the spirit of her grandpa. Since she was little, her grandfather would always say, "I'll see you in my dreams." He wrote it on everything he gave her, even her birthday cards. So what better phrase to get tattooed across her upper back? Baxter wanted to give the lettering an elaborately detailed look, so I really went all out on all the flourishes, trying to add the decorative elements without cluttering the tattoo.

She told me she wanted a big gangsta-looking back piece, so I went all the way with it. I came out of my office and held up the drawing.

"Is this a good size for you?" I asked.

"Fuck, yeah!" she said.

My homegirl, Naheed Simjee.

NAHEED SIMJEE
"HOMEGIRL"

{ "I usually get this concurrent feeling of excitement and nausea when I'm about to get tattooed."
—Naheed Simjee }

I met Naheed Simjee at a tattoo convention at the Hollywood Palladium nearly ten years ago. She was at the point in her life when getting a tattoo of someone's name seems like a good idea. We spoke at that convention about my tattooing her, but I was too busy that day. Naheed gets impatient when she's ready for a tattoo, so she found someone else to do it. The funny part is that she came around and found me a few years later—to cover up that same tattoo with roses!

When she asked me to tattoo the word "homegirl" on her left bicep, it was appropriate, because that's totally who she is to me!

ROXAN MORIN
"PURO AMOR"

{ "I don't wanna hear you whine about getting this tattoo. Get your ass down here!"
—Me, to Roxan Morin }

Roxan Morin's been a dear friend since the Blue Bird Days, back in 1999. I can still remember like it was yesterday the first time she told me about her idea for a rocker.

She asked me to tattoo *puro amor* across her stomach in the toughest Old English-style lettering around. *Puro amor*—Spanish for "pure love"—are the two words I originally wanted tattooed across my knuckles, because these are two beautiful, strong words—and together, they're even better. She'd been talking about the tattoo for years, and now it was time. She was visiting L.A. from her home in New Orleans, and I knew it would be a while before she'd return again. The day I gave her this tattoo, I literally woke her up to get it!

This was the first draft I made for Roxan.
In the end, the hearts fell by the wayside.

JESSE "BOOTS ELECTRIC" HUGHES

"LIL' ROCK 'N' ROLLA, B.1999"

{ "This one was for my son; we did it on *LA Ink*."
—Jesse Hughes }

Jesse "Boots Electric" Hughes is a force unto himself. He is a ball of energy, with personality for days and a heart as big as America. Jesse and I would have sailed together as pirates if we lived on the sea. Everyone knows Jesse as the lead singer for the Russian techno groove reggae band Eagles of Death Metal. People might not know him as the great dad that he is.

The tattoo's lettering, "Lil' Rock 'n' Rolla" is one of his pet names for his son, Micah. Micah is his best friend, and it was my pleasure to give Jesse this super tattoo. We put 1999 in the heart, because that was the year Micah was born. With this tattoo, he's got Micah with him all the time—even when he goes on tour. That means as much to Micah as it does to Jesse.

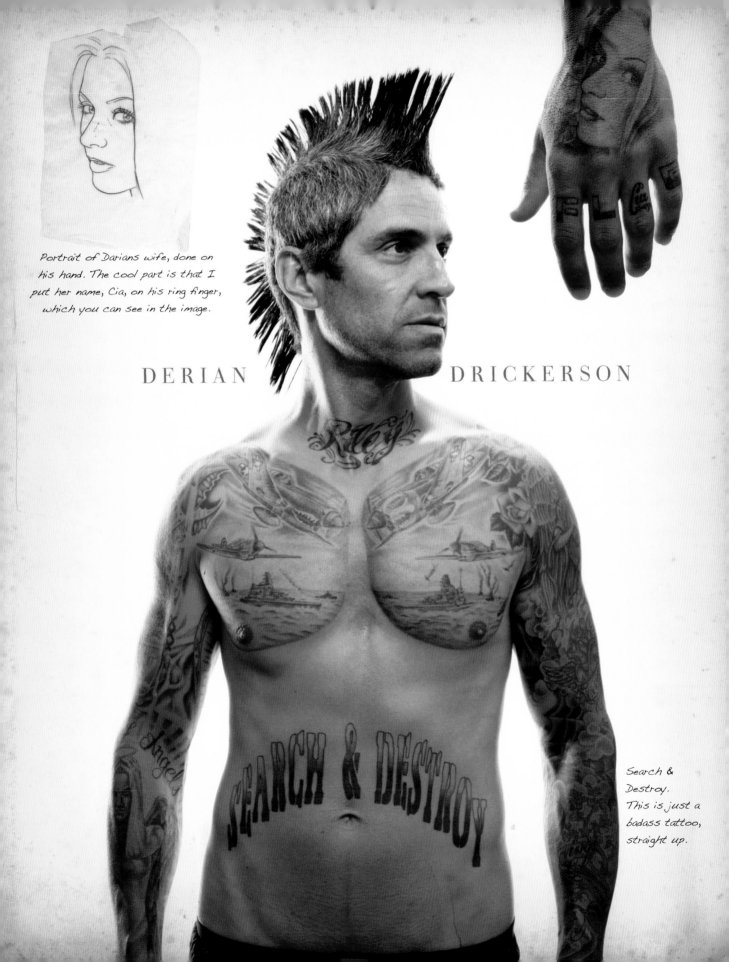

Portrait of Darians wife, done on his hand. The cool part is that I put her name, Cia, on his ring finger, which you can see in the image.

DERIAN / DRICKERSON

Search & Destroy. This is just a badass tattoo, straight up.

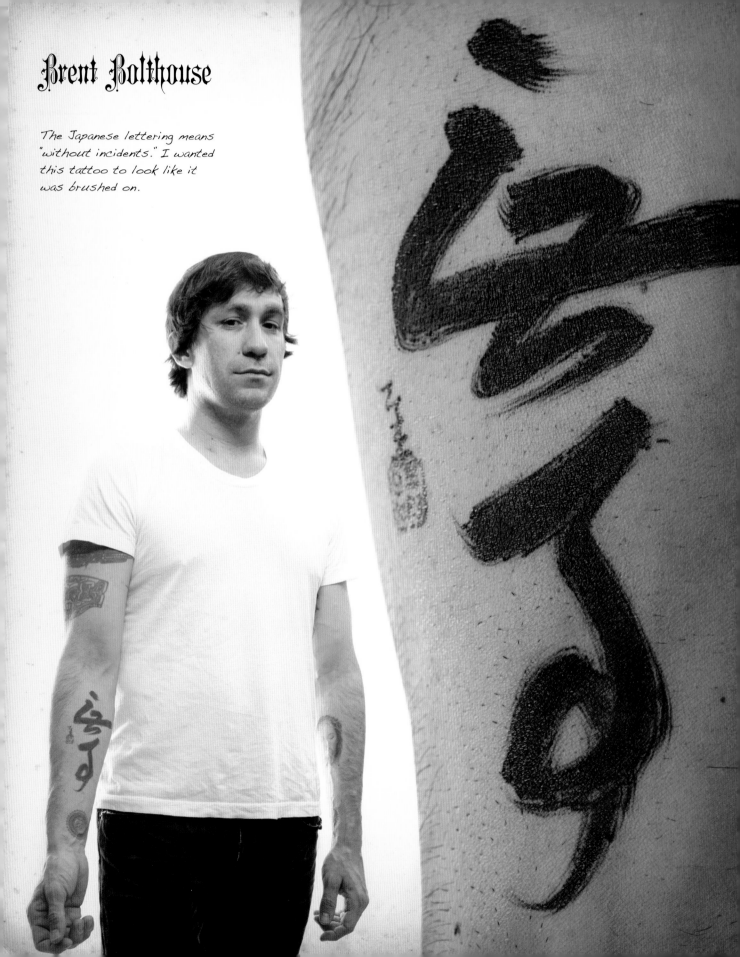

Brent Bolthouse

The Japanese lettering means "without incidents." I wanted this tattoo to look like it was brushed on.

This is Spanish for "I'd rather die on my feet than live forever on my knees."

A rough draft that I did in carney lettering, one of my favorite styles.

Spanish for "My crazy life"; "Life is a dream"; and "family."

A quote by Joan of Arc; I did this on each of Jenna Jameson's shoulders.

This is probably one of the coolest rockers I've ever done.

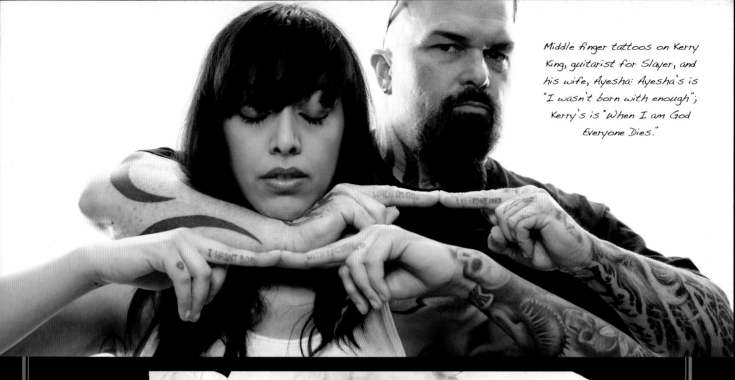

Middle finger tattoos on Kerry King, guitarist for Slayer, and his wife, Ayesha: Ayesha's is "I wasn't born with enough"; Kerry's is "When I am God Everyone Dies."

No explanation necessary!

Spanish for "hopeless romantic."

Spanish for "This is important." I did this on my brother Mike's back.

BRANDON LILLARD
TRADITIONAL ROSE

We used a traditional style of tattooing for pro surfer Brandon Lillard's rose tattoo. He wanted a banner wrapping around the stem with the word "Mom" inscribed on it. His concept stirred me to lean toward the kind of old-school tattooing you would have seen on a sailor back in the 1940s. Even though most traditional pieces are done in color, black and gray gave this tattoo a totally classic vibe.

When I showed Brandon his line drawing, it was way bigger than he expected. But as I always say—go big or go home!

Roses
Whole Lotta Rosie

ROSES ARE, and always will be, a classic design perfect for tattooing. They will never go out of style. They're a unisex subject matter that can be used as the main element in a tattoo, as the background, or as framing.

JASON FREESE
ROSES

"She took a pen and drew circles on my ribs, and then told me to lie down on the bench. All I was thinking was, 'Man, I'm scared!'"
—Jason Freese

The first time I tattooed Jason, I was busy planning a party and in the middle of delegating errands in order to make it happen.

Jason had made an appointment with me to get a few classic black-and-gray roses on his ribs during the time I was working at True Tattoo. He described the roses he was looking for as "somethin' kinda old-school looking, fine-line black and gray." Although he was curious as to how the whole experience would be, I think deep down inside Jason was a little nervous. It's not so much that he doubted my ability to execute his idea to his liking, but just fear of the unknown. I drew on his side, basically mapping out placement for the roses, in order to give Jason an idea of how much room his tattoo would take.

Understandably, it's hard sometimes to have complete faith and use your imagination when all you see is a bunch of scribbles on your body, but I assured him I wouldn't let him down. And I didn't.

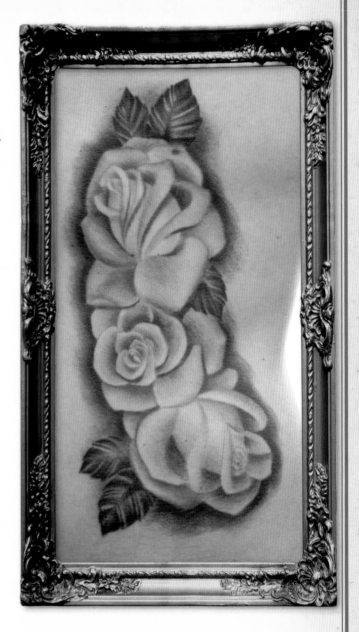

While Kat was tattooing the roses on my side, she was busy explaining to her friend how she wanted to get these cupcakes made for a party that night. They were some kind of porno cupcakes, with naked girls on them. I remember thinking, "Wow, this chick's a crazy party girl! Awesome!"
—Jason Freese

Connie Yandrich used the full-color roses on each side of her lower back as ornaments to centerpiece of lettering. Color roses tend to look a lot bolder than black and gray, but still appear realistic.

For Jeffree Star's roses, I chose to go super-dark on all of the leaves and stems, making them just as important as the rose petals themselves. When it came to shading the petals, it was important to achieve a smooth black-and-gray gradation but the petals looking extremely light; they look like they could even be white!

Hell or High Water: Nautical Tattoos

Because sailors were one of the first few to get so heavily tattooed back in the day, nautical-themed tattoos are prominent in tattoo culture today. Mermaids, anchors, compass roses, clipper ships, and pirate ships are some of the many designs inspired by life on water.

My favorite part of Darren Zimmet's nautical tattoo is the treasure map in the background.

RICHIE SMITH
CLIPPER SHIP

I met Richie during the filming of *LA Ink*. He wanted to get a clipper ship on his back, with a verse from the Bible crowning the top of the piece. Because the process of filming is so long and time-consuming, I rarely get to do massive tattoos, such as this back piece, on the show.

My approach is different when I'm doing a large-scale tattoo instead of, say, a piece on someone's arm. More space to work means more room for creative flourishes, and I tried taking advantage of that when it came to Richie's tattoo by cramming as much detail in confined spaces as possible.

In the back of the ship, for example, we were able to sneak a lot of detail into the ship's carved wood designs. There were the tiny little grooves in the pillars, and tiny flags flying in the wind, as well as tiny birds in the background. I added even more depth by layering the sky with shades of black and gray. All these little details help give Richie's tattoo the perspective that it needs to make the boat look as though it is sailing toward a horizon, or a light.

Thanks to Richie's patience and high threshold for pain, we finished his ship in two sessions!

Detail of Darren's tattoo. X marks the spot!

Opposite: Richie added the Bible verse because, for him, the tattoo represented going towards the light.

Girls Got Rhythm: Pinups

Some tattoo themes go in and out of style, but the pinup girl is always popular because she represents confidence and sensuality at the same time. Many of my tattoos are of nameless women who were born in the imagination of the artist; my entire right calf is covered in portraits of Mexican actresses from the 1950s. I haven't even seen all of their films — I just appreciate their classic beauty and spirit.

Finished Pinup Tattoos

CLOCKWISE:

- Detail shot of a neck tattoo.
- Pinup girl and roses.
- Detail of pinup girl.
- Classic pinup girl.

Hell's Bells

"There is a sacred horror about everything grand."

—Victor Hugo, *Ninety-Three*, 1874

You don't have to be Catholic to feel a connection to an image of the Virgin Mary or Saint Christopher; you don't have to be Hindu to choose Ganesh, or Buddhist to feel drawn to Buddha. An appreciation of religious icons for art's sake has become a popular theme among tattoo collectors.

RELIGIOUS TATTOOS

I have tattooed Egyptian goddesses, Native American spiritual animals, Hindu deities, pagan symbols, the mythological gods of Greece, Jesus Christ, the Virgin of Guadalupe, countless saints, and not a few Michaelangelo-inspired cherubs and angels.

Catholic art is one of my favorite things to collect, draw, get tattooed, and tattoo on clients. As comforting as some of the images of the Virgin Mary or a rosary can be, it's the darker side of this style that inspires me artistically, like a crucifix, a saint, or an anatomical sacred heart. These subjects make for some of the most beautiful tattoos out there.

THE VIRGIN MARY

Whether you used to be a choir boy or you've never even been inside a church, everyone knows this iconic image, and it has made its way into many a tattoo. Whether she is represented traditionally or with some modern updates and flourishes, Mary is a beautiful image to carry on your body. These tattoos are from people of all ages and stripes, and they all wear Mary well.

Line drawing of the Virgin Mary with a white dove of peace.

Full-color Virgin Mary.

Line drawing of the Virgin Mary.

The Virgin of Guadalupe holding a BMX bike; I tattooed this on a pro BMXer.

J ESUS AND THE S AINTS

Elliot Graeber.

Catholic-themed cross with microscopic detail.

Here are more examples of how effective iconic religious images can be when they are tattooed. Elliot Graeber, a client and an avid tattoo collector, particularly of this theme, keeps coming back for more.

ANGELS

FROM EGYPTIAN ANGELS TO THE CELESTIAL CREATURES
IMAGINED BY SALVADOR DALÍ, ANGELS MAKE A BEAUTIFUL TATTOO
NO MATTER HOW YOU TRANSLATE THEM.

Angels and Other Religious Influences

FROM LEFT TO RIGHT: *an Egyptian take on an angel; an Angel holding drumsticks: I designed this for Gas Lipstick, drummer of HIM; an Angel sleeve tracing; Salvador Dali's version of an angel.*

FROM LEFT TO RIGHT: *Ganesh; Day of the Dead line drawings; Tibetan skulls; a sugar skull.*

MANDY GARCIA: ANGEL

{ "This tattoo serves as a guardian angel watching over my family, with each rose representing one of us."
— Mandy Garcia }

An angel is one of my favorite images to tattoo and to get tattooed on myself. Angels, especially based on statues, make for a strong and classic tattoo. Mandy wanted to adorn her angel with a specific amount of black-and-gray realistic-style roses.

"After twenty-eight years of marriage, my parents decided to go through with a divorce which caused a big change in our family," she told me as I was tattooing her. "Even though they don't particularly like tattoos, I still got it for them."

OPPOSITE: *Graphite on paper. I did this in 2008.*

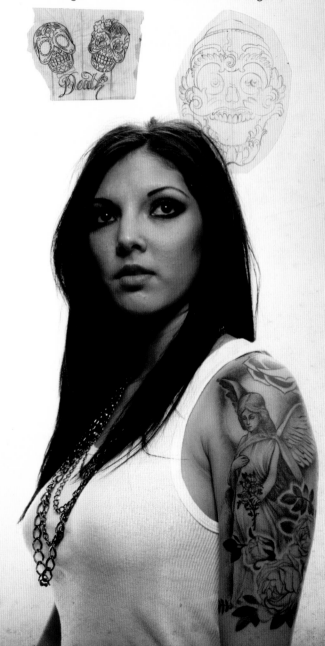

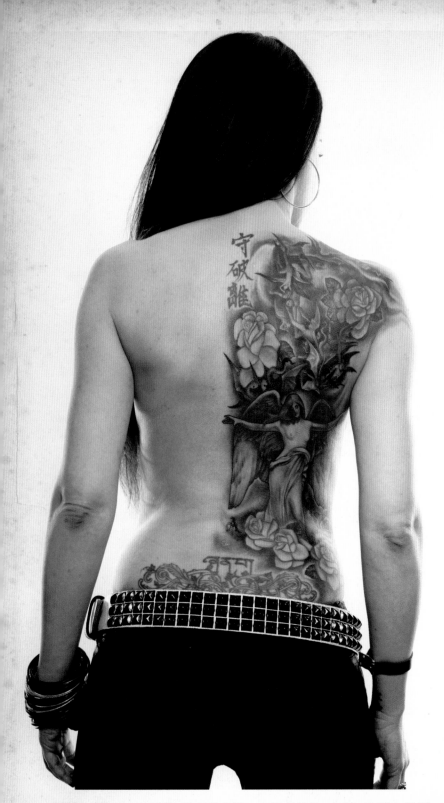

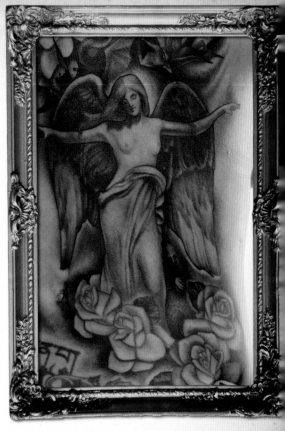

Detail of angel.

KRISTIN MULDERIG: ANGEL OF DEATH

Kristin's dark and foreboding tattoo was inspired by the French artist, illustrator and engraver, Gustave Doré.

 146

Kristin named the creepy character that is coming out of the shadows behind the angel Hector.

NIKKI SIXX'S ANGEL
MAKING A COMPLEX TATTOO

> "I've been wanting to get the words, "Los Angeles," tattooed on me for quite some time now. I came to this city on a Greyhound bus with a dream—and did it. I got married here and had my kids here. I became a drug addict and died here. I recovered here. My whole life has happened in Los Angeles." — Nikki Sixx

Mötley Crüe founder and bassist Nikki Sixx is an avid photographer. Not surprisingly, he likes images that are a bit on the dark side, like old mannequin torsos, doll parts, and weathered statues. In 2006, he came upon an angel in a graveyard in Milan. She towered over him, looking down with a stone countenance, open arms, and a griffin's wingspan. He only snapped two photos of her.

When he first started getting tattoos, Nikki chose them based on symbolism, but lately, he's been refocusing the subject matter based on aesthetics and realism. His photography has played a big role in this evolution.

It's exciting for me to collaborate with Nikki on tattoos. They combine his ideas and my interpretations, and in the end, we're both stoked.

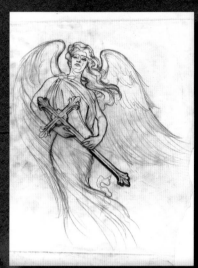

The stencil for Nikki's tattoo.

Because of Nikki's existing tattoos, a tracing of the area of his body was necessary so that I could map out where to place the tattoo perfectly. When I lay the tracing down, I could see the space we would cover. Then it was time to draw the angel.

I made a stencil of the two main focal points for the tattoo: the angel herself, which would take up the majority of his rib cage, and the lettering at the base of his ribs that read "Los Angeles." I would draw the rest of the tattoo directly onto his body to ensure that the flow of the angel's shape would match Nikki's body structure.

Once the basics were set on Nikki in stencil form, I felt like the piece was missing an element. We agreed to add a simple beveled cross. Cradled in the angel's arms, it made perfect sense and completed the piece properly. This was a large piece, measuring about one and a half feet by two feet—it wraps around his whole body from his armpit to his butt cheek! We spent about ten hours on the tattoo—an hour and a half to two hours on each session.

I In the first session, I laid out the line work. When the outline was done, I did a bit of shading on the lettering at the bottom and on the angel's face. I would have kept going, but we were both exhausted after that long session.

2 In session two, I added more shading, focusing primarily on the wings and body of the angel. Already, the added shading made a huge difference in the appearance of the tattoo. Note the aura around her head that wasn't in the original line work.

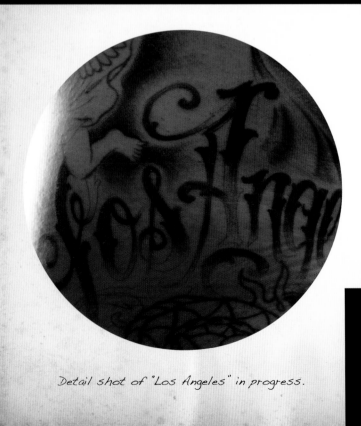

Detail shot of "Los Angeles" in progress.

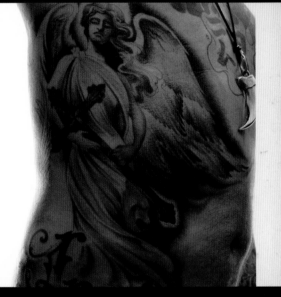

3 In the third session, I worked on more of the shading in t angel and completed most of the shading in "Los Angeles. also started joining this new tattoo with Nikki's preexisti tattoos on his back and upper thigh, so that when we were do with the final session, he would have one big tattoo, getti him one step closer to his final goal — a body suit.

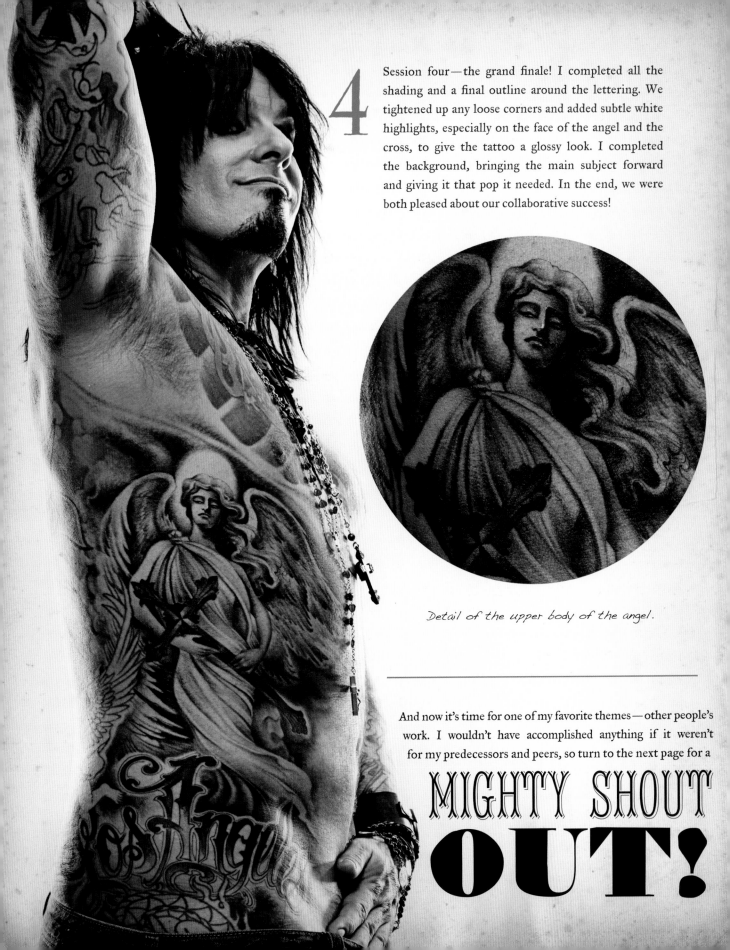

4 Session four—the grand finale! I completed all the shading and a final outline around the lettering. We tightened up any loose corners and added subtle white highlights, especially on the face of the angel and the cross, to give the tattoo a glossy look. I completed the background, bringing the main subject forward and giving it that pop it needed. In the end, we were both pleased about our collaborative success!

Detail of the upper body of the angel.

And now it's time for one of my favorite themes—other people's work. I wouldn't have accomplished anything if it weren't for my predecessors and peers, so turn to the next page for a

MIGHTY SHOUT OUT!

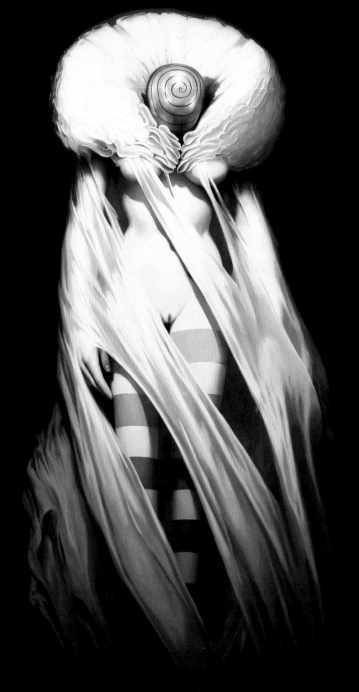

PART V

Michael Hussar's Morphine
72 x 28 inches

The tattoo world comes with its share of politics, in-crowds, leaders, geniuses, and followers. What I hope you've also seen in my book is the strong sense of community. Names repeat because like-minded people who appreciate the same things find one another. Whether you're talking about artists and writers, like Picasso, Matisse, and Gertrude Stein hanging out in Stein's salon to talk and annoy and inspire one another through the night, or the music world, where band members love and fight and make beautiful music, communities arise out of shared passion. And from passion comes incredible art and unavoidable tensions. In the end, though, the good outweighs the bad. The world of tattoo is still a realm of mystery and beauty for me — and the people who inhabit that world are a part of me, too.

In this section, I am stoked to show respect to some great artists I know and love. The profiles that follow, from Shawn Barber, painter-turned-tattooer, to my good friend Kore Flatmo, whom you have already met earlier in the book, to California painter Michael Hussar, represent my community, influences, inspirations, and muses. These artists push themselves to their creative limits, inspiring me to do the same.

And—the most important thing—their work just blows my mind!

DIRTY DEEDS DONE DIRT CHEAP
Artists and Muses

"PICASSO ONCE REMARKED,
'I do not care who it is that has or does influence me as long as it is not myself.'"

—Gertrude Stein, "What Are Masterpieces and Why Are There So Few of Them," 1936

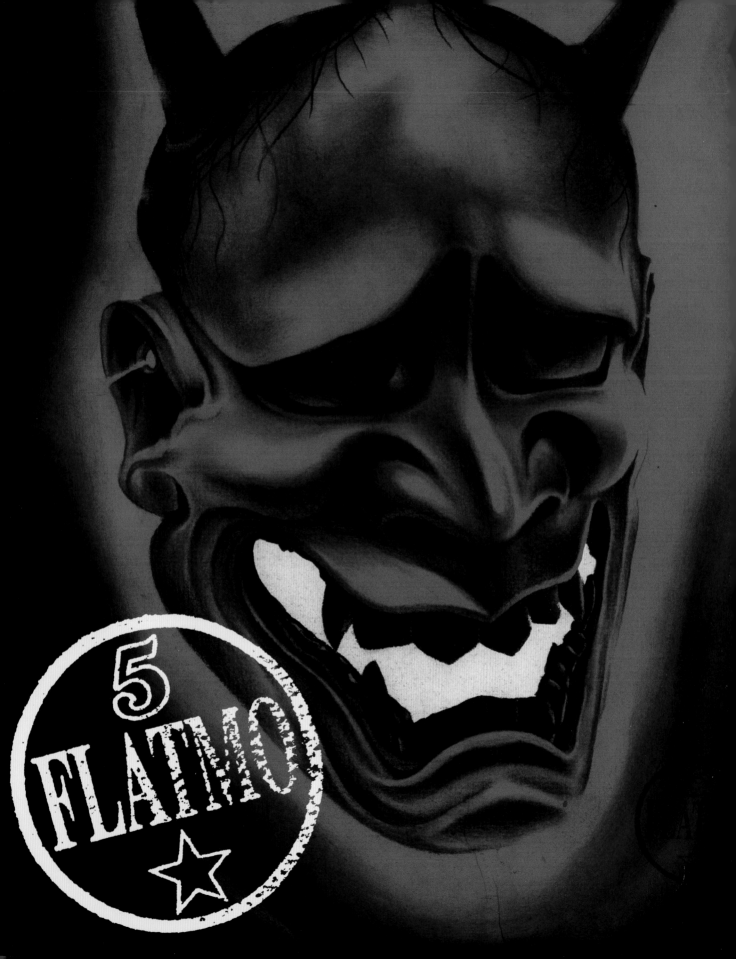

L○VE

I

KORE FLATMO.

I've said it repeatedly, and there are a lot of good reasons for that. He's an artist whom I consider a personal mentor. Kore did a book called *Eighteen Angles of the Human Skull* that I rely on daily for the tattoos that incorporate skulls into their designs. He is a master of his art and one of my most cherished friends.

Year of birth: 1969
Tattoo shop: PluraBella, Cincinnati, Ohio, and Los Angeles
Started tattooing in: 1990
Apprenticed by: Rick Cosmo
Favorite tattoo machine: The machines I use everyday were made by Dan and the good people at Dringenberg & Co. They're reliable and consistent, and they work the way I want them to. I am also partial to my Clay Decker and Invisible Hombre machines.
Favorite pigment: My favorites usually come from friends who have mixed some colors and want to hear feedback. This area is full of guarded knowledge and innovation so it's a good thing to get access to it. The only problem with a one-off batch is when the bottle is empty and the tattoo is unfinished.
Tattoo style: Black-and-gray is my first love, but currently my emphasis is on large-format, heavy-coverage pieces that are tailored to work with the client's form. I like to juxtapose realistic styles with straightforward tattoo backgrounds. I try to utilize natural and unnatural lines, dark and light contrasts, and texture to create clarity and a strong presentation.

Most influential tattoo artists: There are so many outstanding artists who have made a huge impact on me: Cliff Raven, Greg Irons, Horiyoshi II (from Tokyo), Horiyoshi III (Yokohama), Horitoshi, Jack Rudy, Leo Zulueta, the Dutchman, Mick, Trevor McStay, Clay Decker, Kat Von D, Mike Malone, Terry Tweed, Dave Lum, Mike Roper, Henry Lewis, Adam Forman, Julie Moon, Debbie Lenz, Paul Rogers, and Cap Coleman. I could go on for pages. If I had to narrow it down, I would have to say that the most prominent influences on me have been Filip Leu and the strong color and composition of Bob Roberts and Greg James.
Most influential nontattoo artists: To name a few, I really appreciate the work of Caravaggio. I enjoy the sculpture of Bernini and the drawings of William Stout and Bernie Wrightson.
Life motto: Watch your step.
Who has tattooed you: I got my first tattoo in 1988, and over the years I've been tattooed by more than forty different people. I'm proud to say that I've collected beautiful work from some of my favorites, such as Luke Atkinson, Bob Vessels, Greg James, and Clay Decker.
Dream tattoo: That would be a body suit on a client with no tattoos and the money, time, and follow-through to complete the project. That person would also need to have good taste and a well-developed ability to let go and trust me. If all these things fell into place, I think I would have my dream tattoo.

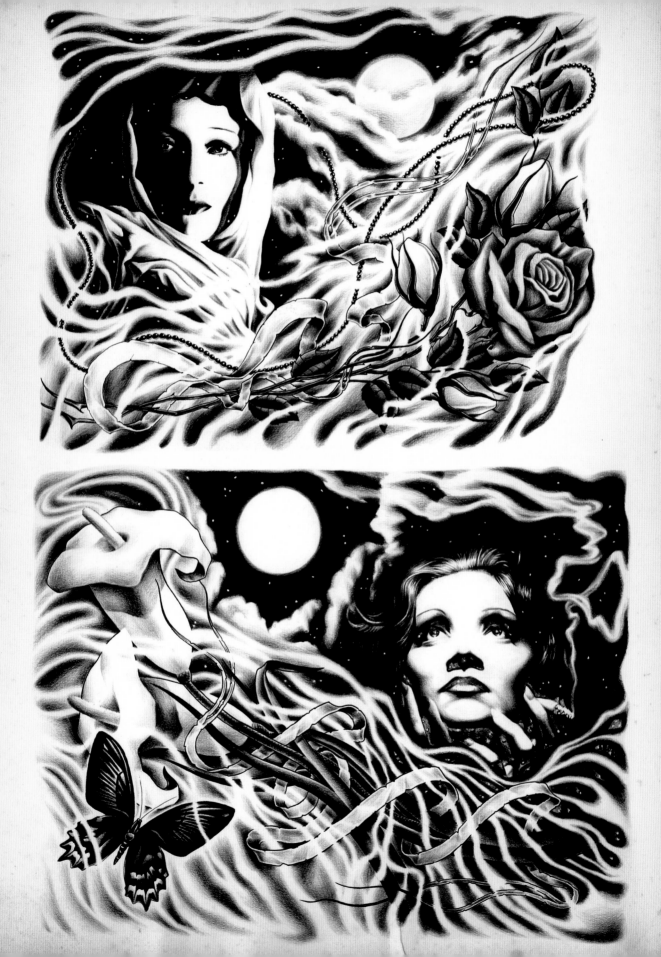

—TO KAT VON D — Thank you for your friendship & beautiful tattoos K. Fletz Nov 2003 * A. P.

PAGE 152: *Hanya mask, charcoal.*

OPPOSITE, TOP: *Joan Crawford, black color pencil.*

OPPOSITE, BOTTOM: *Marlene Dietrich, black color pencil.*

ABOVE: *Portrait of Edith Burchett as Ana Livia, watercolor.*

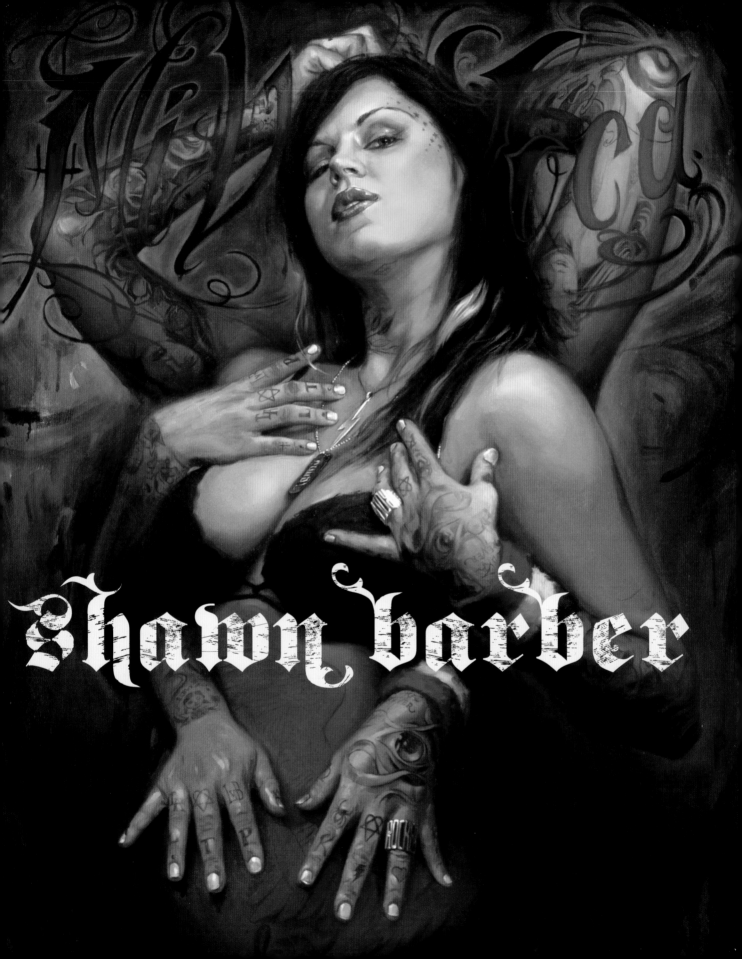

Shawn Barber has had a long relationship with the world of tattoo even though he's just started tattooing. A fine painter who captures the art—and the artists—of tattoo on canvas, when he decided to become a tattoo artist himself, I couldn't wait to see what he would do. His painting style is lush and realistic, and I love the fact that he paints tattooed portraits. I have two of his paintings in my collection at my shop. As I write, he is working on two more portraits of me that I've already called dibs on. One of them will be my first nude; the other is a close-up of Nikki and I holding hands with all of our tattoos captured for posterity.

Year of birth: **1970**
Tattoo shop: **Everlasting Tattoo, San Francisco**
Started tattooing in: **2007**
Apprenticed by: **Mike Davis**
Favorite tattoo machine: **No comment.**
Favorite pigment: **No comment.**
Tattoo style: **No comment.**
Most influential tattoo artists: **Don Ed Hardy, Filip Leu, Kore Flatmo, Grime, Paul Booth, and Marcus Pacheco.**
Most influential nontattoo artists: **Velázquez, Anthony Van Dyck, Alphonse Mucha, John Singer Sargent, Egon Schiele, Jerome Witkin, Jenny Saville, and Andrew Wyeth.**
Life motto: **"Happiness comes from sincerity, an awareness of self, humility, and a sense of doing what's right for you. Understanding that every choice has a consequence and believing confidently in knowing that you will fail at times, but also that by choosing to believe in yourself, you can't go wrong. Equally, I can be nothing more than an example."**
Who has tattooed you: **Henry Lewis, Bryan Bancroft, Kim Saigh, Phil Holt, Paul Booth, George Campise, Kat Von D, Mike Wilson, and Nikko Hurtado.**
Dream tattoo: **No comment.**

NIKKO
HURTADO

Year of birth: **1980** Started tattooing in: **2002** Tattoo shop: **Ignition Tattoo, Apple Valley, California**
Apprenticed by: **No comment.** Favorite tattoo machine: **Aaron Cain's "Mecho."**
Favorite pigment: **Eternal Ink and Intense Ink.** Tattoo style: **Photorealism in general as well as full-color portraits.**
Most influential tattoo artists: **Bob Tyrrell, Robert Hernandez, Guy Aitchison, and Paul Booth.**
Most influential nontattoo artists: **Shawn Barber, Kevin Llewellyn, and Michael Hussar.**
Life motto: **I do what I want.** Who has tattooed you: **Mike Damsi, Robert Hernandez, Bob Tyrrell, Nick Baxter,
Nick and Adrian Dominic, Mike DeVries, and St Marc.** Dream tattoo: **I would love to do a full-themed body
suit that is surreal and flows with the body.**

I've always admired Nikko's approach to color and photorealism. Seeing his tattoos in the tattoo magazines is nothing compared to the real thing. I had always heard about Nikko—this guy who supposedly had only been tattooing a few years but was taking portraits to the next level. The first time I saw an example of his work in person, it blew my mind—the images are so lifelike you would swear they are looking back at you. Nikko is a painter as well as a tattoo artist, and this can only help his appreciation of color.

Lots of tattooers take a stab at doing a color portrait and fail, creating a tattoo that either isn't true to the photo or won't withstand the test of time. It can be difficult to make a full-color tattoo look realistic and not cartoony, but Nikko has a knack for it. He has an innate sense of color and layers the most lifelike tones I have seen. I don't understand his approach, but sure do wish I could tattoo that way!

HANS

ca ★ 1440

14' △ ★ 1494

MEMLING

Memling, 18 x 14 inches.

ΜICHÆL

"Art is a structure built on the backs of every artist, living or dead. . . . It's an apparatus of ideas, woven together with golden threads of dialogue. It's about the discussion that surrounds the object or idea, but not the object itself. The irony is, the best shit always leaves them speechless."

—MICHAEL HUSSAR

HUSSAR

YEAR BORN	1666
LOCATION	PASADENA, CALIFORNIA
YEARS PAINTING	FIRST PAINTING DONE IN 1970
FAVORITE MEDIUM	OIL PAINT AND MAKERS MARK OR JAEGER
STYLE	AMERICAN BAROQUE
MAIN INFLUENCES	ANTHONY VAN DYCK, HANS MEMLING, VELÁZQUEZ, THE USUAL
LIFE MOTTO	OVERKILL

ichael Hussar has been one of my biggest artistic influences over the years. He might not be a tattoo artist, but he's definitely one of my tattoo muses. Combining realism and fantasy, his art translates perfectly as a tattoo. Many tattooers use renditions of his art in their work, and my list of dream tattoos would consist of any and all of his pieces. The subject matter is what attracts me — it's so creepy and loaded — and his ability to combine fantasy and realism is really incredible.

I had always wanted to own one of his paintings. I attended the opening of *Red Red Robin*, his 2006 solo show, in the hopes of being one of the select collectors who would take home a piece from the exhibit that evening. As usual, life gets in the way of life and I was running behind schedule. I booked it to Pasadena from Hollywood as fast as I could, arriving late but just in time to find that the entire show had sold out.

Luck proved to be on my side that evening, though, when I was handed the night's program, along with the price list. The program itself was laid out beautifully. Tattoo-influenced gold script spelled out "Red Red Robin" at the top, while one of Michael's oval-framed paintings of a woman's eye filled the rest of the page. The eye had a tiny little star that reminded me of the star tattoos I have on my temple near my own eye. That painting was made for me and he didn't even know it. "He better not have sold this painting yet!" I thought.

Weaving my way through the crowd, I made my way to the painting of the eye with the star: lo and behold, there was no red pushpin next to it indicating it had been sold! That night I bought *Go-Go*, the first of my Michael Hussar collection. Several months later, I met Michael; his talent is matched with a refreshing modesty and humility.

Michael Hussar taught at the Pasadena Art Center for nearly ten years and instructed many of the big players in L.A.'s low-brow, figurative realist scene and beyond. Today he continues to paint, teaching workshops internationally from San Francisco to Prague.

TAKAHIRO

KITAMURA

HORITAKA

oritaka, or Taki as his friends call him, is known for having the best-quality tattoo books for tattooers, like *Underway is the Only Way*, *The Sketches of Horiyoshi III*, *Horiyoshi III*, and more, always featuring a good representation from the international cast of A-list tattoo artists. He also organizes the San Jose Tattoo Convention, and when I put my own tattoo convention together in 2007, show was the bar I was aiming for. He's a big part of the tattoo community, and his tattooing kicks ass!

Year of birth: **1973**
Tattoo shop: **State of Grace, San Jose, California**
Started tattooing in: **1998**
Apprenticed by: **Horiyoshi III, thanks to Paco Excel for starting me out.**
Favorite tattoo machine: **Anything Juan Puente touches.**
Favorite pigment: **National.**
Tattoo style: **I strive to tattoo in a manner that both embodies and respects the Japanese tattoo tradition.**
Most influential tattoo artists: **Yokohama Horiyoshi (Yoshitsugu Muramatsu), Horiyoshi III (Yoshihito Nakano), Horitomo (Kazuaki Kitamura), Don Ed Hardy, Jack Rudy, Bob Roberts, Horiyuki (Jill Mandelbaum), Colin Kenji, Juan Puente, Chad Koeplinger, and Dan Wysuph.**
Most influential nontattoo artists: **The Japanese masters: people like Hokusai, Kyosai, Kano Hogai, Soga Shohaku, Yoshitoshi, Kuniyoshi; Toyokuni III is a personal favorite. As far as Western art goes, I really like Edvard Munch; I am also a huge fan of Nabokov, Raymond Carver, and Zadie Smith.**
Life motto: **Underway is the only way.**
Who has tattooed you: **Horiyoshi III, Horitomo, Horiyuki, Don Ed Hardy, Jack Rudy, Chad Koeplinger, Juan Puente, Chris Brand, Dan Wysuph, Colin Kenji, Chuey Quintanar, Freddy Corbin, Grime, Adrian Lee, Paco Excel, Mike Wilson, Aisea Toetu, Wrath, Timothy Hoyer, Jason Kundell, Mark Mahoney, Derrick Snodgrass, Jason McAfee, Mike Malone (RIP), and too many more to list.**
Dream tattoo: **Something like what Horitomo does on a daily basis.**

JA CK Mosher

HORIMOUJA

Year of birth: 1969 Tattoo shop: Body Armor Tattoo, Kalamazoo, Michigan
Apprenticed by: Self-taught, meaning that I learned from many people! Started tattooing in: No comment.
Favorite tattoo machine: Soba, Micky Sharpz, handmade machines from Dennis from Germany, and Pele—his rotary machines are great! Favorite pigment: Eternal Inks and National.

JACK MOSHER self-publishes books that are primarily art reference books; they're an incredible resource for Japanese-style tattooing. Each book focuses on a specific subject such as dragons, koi, or hanya masks, among others. I've never seen more perfectly executed line work or more consistent color. I dare anyone to look at his tattoos and find a flaw. One of the things about Jack that I love the most is his work ethic. He works so hard and creates such incredible tattoos. Everybody loves to be his colleague! When he joined us at High Voltage as a guest artist, the entire crew was sad when it was time for him to go.

Tattoo style: Modern Japanese style (I call it Jacka-nese). Originally, I was heavy into ethnic tribal designs, but on a trip to Japan to study Tebori hand techniques I fell in love with the imagery and the stories behind the Japanese-style tattoos.

Most influential tattoo artists: I have been influenced and inspired by so many that to make a list would be untrue to all!

Most influential nontattoo artists: Frank Frazetta, Simon Bisley, Mark Shultz, and, of course, Hokusai, the original art warrior!

Life motto: To leave a positive influence on the generations to come!

Who has tattooed you: Luke Atkinson at Checker Demon (Germany), Leo at Naked Trust (Austria), Jeroen Franken (Netherlands), Horiyoshi III (Japan).

Dream tattoo: Designing a full Japanese style body suit for a client.

Year of birth: **1963** Tattoo shop: **Night Gallery, Detroit, Michigan** Started tattooing in: **1997**
Apprenticed by: **No comment.** Favorite tattoo machine: **The two Micky Sharpz machines I've used for the last ten years.**
Favorite pigment: **I swear by Pelikan ink. I've been using it since day one.**
Tattoo style: **Black and gray, photorealism, portraits, and freehand horror imagery.**
Most influential tattoo artists: **Paul Booth, Robert Hernandez, and Tom Renshaw.**
Most influential nontattoo artists: **Frank Frazetta, H. R. Giger.** Life motto: **I live a really simple life. I just want to tattoo, play guitar, do some art, travel my ass off, drink a few beers, and hang out with my friends and family.**
Who has tattooed you: **Paul Booth, Mario Barth, Robert Hernandez, Tom Renshaw, Cap Szumski, Corey Miller, Kim Saigh, Jeff Gogue, Craig Helmich, Jeremiah Barba, and Jovanka.** Dream tattoo: **I always wanted to do a Keith Richards portrait, and just finally did one. But I still want to do one of Keith as he looks now, with all the wrinkles and texture in his face — and his crazy hair.**

BOB TYRRELL

I first met Bob Tyrrell on the tattoo convention circuit. When I'd walk past his booth, it was almost a guarantee that there he'd be, diligently working on a tattoo, creating either a beautiful rendition of a loved one's portrait or a gnarly half-demon-half-zombie chick on a client—almost 100 percent of the time in black and gray.

"I did a lot of color the first few years tattooing, working in a busy street shop, you had to," Bob says. "But over the years I've phased out color, and now I do a color piece once or twice a year. I really do prefer black and gray, I always have. I can get a lot more depth with it. Plus, it makes traveling a lot easier—a bottle of black ink and a bottle of white for the highlights!"

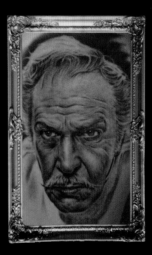
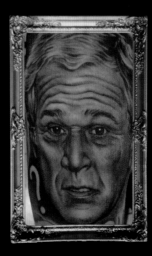
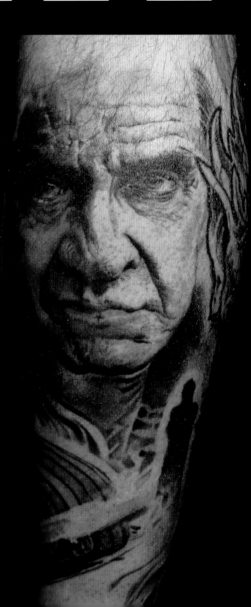

The International World of Tattoo

There are a lot of tattoo artists out there across the big blue and green globe who are shaking the foundations of tattooing on a daily basis. They are in their studios creating their magic in places like Brisbane, Vancouver, Lausanne, and Osaka. But because TV shows like *LA Ink* air worldwide, inviting the international public into the American tattoo world, there are people who think that the tattoo scene is concentrated in the United States. That's too bad, because a lot of really amazing tattooers and their incredible work are neglected in the process, especially the ones from other countries. These talents shouldn't be ignored! If people only knew how bad-ass some of these artists are I'm confident that they would be more inclined to save their frequent flier miles for tickets to South America, Europe, Asia, or Australia in pursuit of the perfect tattoo.

EUROPE

FRANCE
TIN-TIN (PARIS)

Tin-Tin is one of the biggest names in tattooing. I've seen amazing black-and-gray work from him. He's been around a long time, and his mastery of the form really shows in his work. From gorgeous dragons and geisha girls to whimsical illustrations and perfectly rendered portraits of animals, Tin-Tin's work is awesome. In fact, if you're planning a trip to Paris, I'd say to skip the Eiffel Tower and head straight to Tin-Tin Tatouage.

Germany

LUKE ATKINSON (STUTTGART)
Luke Atkinson has to be one of the most underrated tattooers: His high level of humility matches his amazing talent. His Japanese style of tattooing is incredible, and I was really fortunate to have him be a part of Musink in its first year. I was first introduced to Luke by Kore Flatmo when I was eighteen and have been a fan ever since.

Spain

ROBERT HERNANDEZ (MADRID)

One of my favorite tattooers is Robert Hernandez. He works at Vittamin Tattoo. He did one of my Beethoven portraits on my right thigh—and I couldn't believe his approach to tattooing. He took a ball point pen, drew a few lines—maybe two or three—then just went off creating the perfect spitting image of what Ludwig van Beethoven would have looked like—if he were a zombie. Looking through Robert's portfolio online, it was mindboggling to see how much it displayed a huge number of portraits done to a tee. There are so many of them that he has them grouped by themes such as music, movies, religious, and more. He has mastered both black-and-gray portraits and full-color photo realism

SWITZERLAND

FILIP LEU (LAUSANNE)

I have only met Filip once. I was eighteen when Juan Puente, a tattooer from Los Angeles and a good friend, let me tag along with him to the annual tattoo convention in Milan. Even if it is not possible to the best in the world at anything, because someone is always better than someone else, if I had to say who was world's best tattoer, I'd have to name Filip Leu. Filip comes from a tattoo family. His father (RIP) Felix Leu was a highly respected tattooer whose death affected the entire tattoo community. Filip started tattooing at the age of ten—he was taught the art by his family. His wife, Titine Leu, is also a tattooer and a very talented painter. Although Filip is known primarily for his skills in the black-and-gray department, he can do anything!

UNITED KINGDOM

MO COPALETTA (LONDON)

Mo Copaletta works in London, and he's originally from Italy. He's got great personal flair—he's probably one of the most stylishly dressed tattooers I know. Every piece they do at Mo's shop, The Family Business, is custom. Mo's color tattoos are just incredible, with close detail and lush, vivid colors that make the images jump from the skin.

LAL HARDY (LONDON)

Tattooing the likes of everyone from Jack Osbourne to your favorite rugby/football player, Lal is the man to go to in London. Specializing in everything from old school traditional style tattoos to Japanese to black and gray, Lal's shop does great work in almost any style you could ever want.

ASIA

Japan

SHIN-JI, HORI YOSHI (HORI YOSHI FAMILY) (OSAKA)

The crew at Three Tides are only some of the most amazing Japanese style tattooers in the business. They are also the first modern street shop to specialize in custom tattooing, and their work really helped Japanese tattooing make it to the mainstream. If you are looking for the real deal Japanese style tattoos, go to the source. These are the guys to check out; their style is graceful, potent, and fantastical.

AUSTRALIA
LOZ (BRISBANE)

Loz lives in Australia and works at Westside Tattoo, so I had to wait until he did a guest spot at True Tattoo to meet him in person. And I was glad I did, because I got to watch him tattoo an amazing portrait of Roy Orbison that really blew my mind. Awesome!

NORTH & SOUTH AMERICA

CANADA

THE DUTCHMAN (BURNABY, B.C.)

John van't Hullenaar (the Dutchman) launched Dutchman Tattoo over twenty-five years ago, and he's been setting standards for Canadian standards since—forever. His work covers a range of tattoo styles, everything from the traditional to the tribal, custom work to photographic. He's crazy talented, and his work proves it! The Dutchman has gotten tons of awards for his tattooing, and if you check his gallery online, it's not hard to see why.

STEVEN MOORE (VANCOUVER, B.C.)

Steven Moore is the tattoo world's official "nice guy." He's also a huge talent, with a style that lends itself just as well to portraits of Winston Churchill as it does to windswept geisha girls. He got his start tattooing in Toronto, and now he works out of a private studio, Imprint, Inc., in Vancouver. So if you ever find yourself in Vancouver with a blank space on your back…

Brazil

JONATHAN SHAW (RIO DE JANEIRO)

Like a traveling gypsy pirate, the son of the late jazz musician Artie Shaw, Jonathan rules the tattoo world of Brazil. Even though he started his tattoo career in America in the 70s, his passion for writing made him gravitate to Rio where he found his main inspiration for literature—a crack-whore prostitute. Jonathan Shaw is known for his unique tattoo style that covers a broad range of styles including lettering and full-color traditional Americana. His images are bold and striking. One of his signature tattoos is the Jonathan Shaw skull, recognizable by any tattooer. Getting an appointment with Jonathan is slim to none, though, because he's rededicated his life to writing amazing memoirs including *Scab Vendor: Memoirs of a Tattoer* and *Narcissa, Lady of the Ashes*—both of which are deeply rooted in the tattoo world.

Kissin' Dynamite:

So here you have it — my life, my loves, my music and my art. Tattooing is my life, and Love is my higher power. Tattooing started as an experiment, but then it absorbed me completely. When I tattoo, I put on my music, and I fuckin' listen —— I listen to my music, and I tattoo, and I got lost in my tattoo.

My skin is a magic mirror that reflects where I have been, and now I'm staring forward into the future —— and it's big, bad and beautiful.

And that's the way I wanna Rock n Roll!

Con Amor,

Kat Von D

Acknowledgments

Many thanks to:

ELIZABETH SULLIVAN, for coming up with the idea for this book and for sticking to your guns by thinking outside the box, regardless of what anyone else said.

LIONEL DELUY, for always making me look my best and for being one of the most selfless human beings I have ever met.

ANDREW TONKERY, for being Lionel's right-hand man.

SANDRA BARK, for your willingness to make the time for me when I was in dire need. You are like Beethoven when it comes to the composition of words. My partner in crime!

REBECCA OLIVER, for your patience, your faith in me and in the book, and your ability to pull rabbits out of hats! I wouldn't have met Liz or Sandra if it weren't for you!

RHIAN GITTINS, for always saving my ass. If it weren't for you, I wouldn't have the balls to do half the shit we have done together so far. DILLIGAF.

NIKKI SIXX, for teaching me so much, being my best friend, and helping me believe in love and faith again.

BAM MARGERA, for being one of the few people I can relate to on this planet and for being a true friend, even before all of this shit . . . Little Champion!

TOM GREEN, for the inspiration and the company when I truly needed it.

KORE FLATMO, for being the ultimate standard in tattooing.

JOHN AUSTIN, for always listening.

ADRIENNE IRONSIDE, for your constant support, especially through the big "C" scare.

JESSE "BOOTS ELECTRIC" HUGHES, for getting me.

EMILY, for changing my entire outlook on life. You are the only person I wish I could have met.

OLVERA CANDLE SHOP, my favorite candle source in L.A.

IVO FISCHER, for teaching me to trust a man in a suit.

BRAD LYON, for always going above and beyond, not because you gained anything, but because you wanted to help me: the shop, the divorce, the mom, the cash register, and everything else.

DISCOVERY/TLC, for helping me show my Dad what it is that I really do.

HIGH VOLTAGE TATTOO B-CREW, for being the family I always wanted to be a part of and for holding down the fort for me. Friendship, Love, and Truth.

WILL STAEHLE, for being more creative then I ever could be.

SHALYA SCUFFI, for nourishing us with your amazing cooking skills.

TANYA DEMERIS (president of the Kat Von D Fan Club), for truly being my biggest fan and supporting me when no one else did.

KAT VON D'S WEB SITES

Kat Von D's official web site:
www.katvond.net

Kat Von D on MySpace:
www.myspace.com/katvond

Kat Von D Fan Club:
www.theofficialkatvondfanclub.com

High Voltage Tattoo:
www.highvoltagetattoo.com

High Voltage Tattoo on MySpace:
www.myspace.com/highvoltagetattoo

Kat Von D's clothing provided by
www.agathaleather.net
www.royalunderground.com
www.rokkclothing.com
www.tonysshoes.com
www.whitetrashcharms.com.

Kat Von D's makeup by
Jeffree Star, using
Kat Von D for Sephora makeup:
www.sephora.com

Kat Von D's hair and extensions by
www.ConstanceEva.com

Photography of Kat Von D
by Lionel Deluy
www.lioneldeluy.com

High Voltage Tattoo

COPYRIGHT © 2009 BY KAT VON D

All rights reserved. No part of this book may be used or reproduced in any manner whatsoever without written permission except in the case of brief quotations embodied in critical articles and reviews. For information, address Collins Design, 10 East 53rd Street, New York, NY 10022.

HarperCollins books may be purchased for educational, business, or sales promotional use. For information, please write: Special Markets Department, HarperCollins*Publishers*, 10 East 53rd Street, New York, NY 10022.

First published in 2009 by
Collins Design
An Imprint of HarperCollins*Publishers*
10 East 53rd Street
New York, NY 10022
Tel: (212) 207-7000
Fax: (212) 207-7654
collinsdesign@harpercollins.com
www.harpercollins.com

Distributed throughout the world by
HarperCollins*Publishers*
10 East 53rd Street
New York, NY 10022
Fax: (212) 207-7654

Library of Congress Cataloging-in-Publication Data

Von D, Kat, 1982-
 High voltage tattoo Kat Von D
 p. cm.
 ISBN 978-0-06-168438-8
 1. Von D, Kat, 1982- 2.
Tattoo artists--United States--Biography. 3. Women tattoo artists--United States--Biography.
4. Tattooing--United States. I. Title.

 GT5960.T362U6 2008
 391.6'5--dc22

2008026559

Book Design by L O N E W O L F B L A C K S H E E P

Printed in the United States of America
Third Printing, 2009